powerful
page **DESIGN**

1 47 114 00 64 12 56 318 3435 87 5 768 92 175 848 35

TOP DESIGNERS LAY OUT THEIR CONCEPTS
TO REVEAL THEIR INSPIRATIONS

BY GAIL DEIBLER FINKE
AND CLARE WARMKE

HOW
DESIGN
BOOKS

DESIGNED BY LISA BUCHANAN

powerful page**DESIGN**

TOP DESIGNERS LAY OUT THEIR CONCEPTS TO REVEAL THEIR INSPIRATIONS

50% 50% **B** 50% 50% Balance Kreuzmiren C 50% 50% IVI 50% 50% 25% 75% 50% 50% **B** 50% 50% Balance Kreuzmiren 25% 75%

a multimedia lecture on the ori

day yyyyyyy June 30, 2000 ooooo

powerful
page DESIGN

1 47 114 00 64 12 56 318 3435 87 5 768 92 175 848 35 6 43 1

TOP DESIGNERS LAY OUT THEIR CONCEPTS
TO REVEAL THEIR INSPIRATIONS

BY GAIL DEIBLER FINKE
AND CLARE WARMKE

DESIGNED BY LISA BUCHANAN

HOW
DESIGN
BOOKS

Other fine HOW Design Books are available from your local bookstore, art sup-
ply store or direct from the publisher. Visit our Web site at www.howdesign.com
for information on more resources for graphic designers.

06 05 04 03 02 5 4 3 2 1

Library of Congress Cataloging-in-Publication Data
Finke, Gail.
 Powerful page design : top designers lay out their concepts to reveal their
inspirations / by Gail Deibler Finke and Clare Warmke ; designed by Lisa
Buchanan.
 p. cm.
 Includes indexes.
 ISBN 1-58180-258-7 (alk. paper)
 1. Commercial art—History—20th century. 2. Graphic arts—History—20th
century. 3. Computer drawing. I. Warmke, Clare. II. Buchanan, Lisa. III. Title.

NC998.4 .F55 2002
741.6—dc21

 2001039557

Edited by Clare Warmke
Editorial Assistance by Ruth Belanger and Ava Mueller
Production by Emily Gross
Designed by Lisa Buchanan
Page Layout by Kathy Bergstrom

The permissions on page 139 constitute an extension of this copyright page.

ACKNOWLEDGMENT/DEDICATION

Thanks to Scott, Meghan and Marshal, who make
everything worthwhile; to all the designers who
created these pieces and the clients with the fore-
sight to hire them; to my editors at F&W
Publications; and to St. Francis de Sales—patron
saint of writers—for inspiration. I hope this book
will provide even more inspiration.

table *of* **CONTENTS**

143 064 74 562 10 8537 140 425768 1061759142 4 8 13513943 15

Even design that deliberately hides its ostensible message reveals another one, a message about the kind of person or company that commissioned it and the kind of person expected to read it.

Every designed piece, from a simple claim check to a year-long marketing campaign, communicates a message. It's the designer's job to communicate that message, usually as quickly as possible. Though these messages aren't always obvious to their audiences (the average person doesn't think much about how paper opacity affects him or about why a typeface does or doesn't appeal to her), they come through loud and clear to the trained eye. A good designer can look at a box of cereal or a direct marketing campaign and see how it fails. An even more important skill is to be able to tell why a piece succeeds.

Design touches people on an emotional level, inspiring feelings without using words. Good designers know how to make type tell a story, to create a mood with color, to let layout pace a message, to find images that convey emotion. Good designers also know how to analyze other people's designs and how to see what design choices enhance or obscure the message.

In this book, you'll find more than one hundred great designs that communicate messages of all sorts. Their creators reveal the nuts and bolts of how each piece was made from the typefaces to the substrates. But more importantly, you'll discover what gives each piece its emotional punch.

Armed with that understanding, you'll be better able to tackle your own projects. More specifically, you'll be better able to look at the messages you have to communicate and to figure out how best to reveal them through the tools of your trade.

As you flip through the pages of this book, you'll discover that communicating a message is the key to designing well. Evaluate each designer's work with this in mind: "What message does this design communicate?" This form of critical thinking may lead you to the revelation you need to revive your own projects.

While looking for a design's message, remember that you can tell a good design from a bad one by its results. Those results can be simple: A neat claim check gives people the confidence to leave their dry-cleaning behind. They can also be complex: An effective marketing campaign convinces company executives to invest millions of dollars, not only by promising high returns but by assuring them that the project or product reflects the company's goals, the producer is trustworthy and the public will welcome it.

Although skill is important, it takes more than skill to create effective emotional reactions. It also takes understanding. Some designers have an intuitive understanding of how people react to design. Others study long and hard to learn it. However it's gained, that understanding is an essential part of good design. Let yourself react to the art on the next 128 pages and see how the designers guided your response. Then get back to work, ready to reveal your next stellar piece of communication design!

WHITE GAS

INOX

PARTICLE

CO:LAB

ERIC ROINESTAD DESIGN

PETER SCHMIDT STUDIOS

STUDIO INTERNATIONAL

SUNSPOTS

TAYBURN DESIGN

LEWIS MOBERLY

AUFULDISH & WARINNER

MASTANDREA DESIGN

DEE & ALISON GRAPHICS

STUDIO NORTH

SUNSPOTS

IRIDIUM

LOUEY/RUBINO DESIGN

chapter *1* CONCEPT

1 47 28 00 64 12 56 318 3435 87 5 768 40 175 84 835 43 15

Sometimes it takes just one design element—one letter, one photo, one illustration—to reveal what a piece is about. Who doesn't admire such master-pieces of minimalism? They reduce every message down to one image that explains everything, one symbol that encompasses what would take para-graphs to explain.

But this isn't always the best approach. Some messages are better explained with a myriad of visual and even tactile elements. Working together, many parts can reveal one whole. Sometimes the message can be immediate. Sometimes it reveals itself bit by bit as the user examines the piece. And sometimes the message isn't clear until the last moment, when one final image, word or embossed back cover suddenly reveals all.

Whether the message is joyful or somber, this multifaceted piece is a delight for the reader. It's the print equivalent of a building by a master architect: every part, from the feel of the paper to the luster of the ink, works together to create a meaningful whole. The projects in this chapter use every design element to reinforce a strong con-cept, communicating it at the reader's first glance and carrying it through to his last.

Studio	White Gas
Designers	Mark Todd, David Shields
Illustrators	Mark Todd, David Shields
Photographers	Mark Todd, David Shields
Text	Mark Todd
Client	Self
Software	Adobe Photoshop, QuarkXPress
Paper	Karma
Colors	Two, match
Print Run	500
Cost Per Unit	$24
Type	Franklin Gothic, found type
Special production technique	Cover photo tipped on
Special type technique	"Resist the urge to straighten unneccessarily."

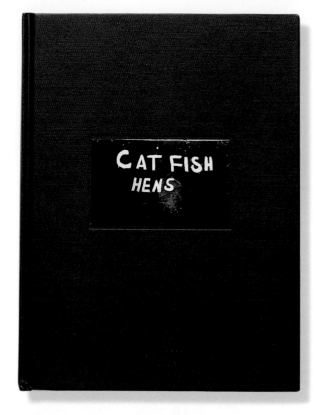

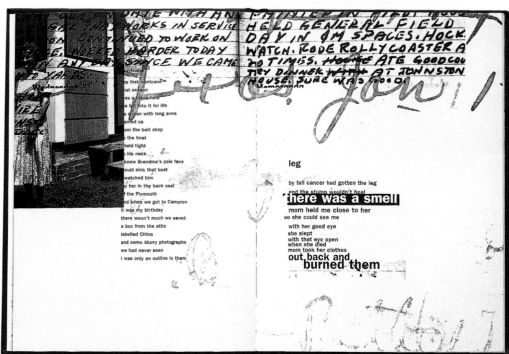

"This book was created under duress," the dedication page reads, and it shows. Photographs and scraps—found illustrations, notes, doodles and seemingly unrelated art—accompany a collection of dark poems, most of them about death. The result is an unsettling piece that makes the reader want to stay away from circuses and musty rooms. "Special thanks to Junior for the writing and the goats," offer creators Mark Todd and David Shields.

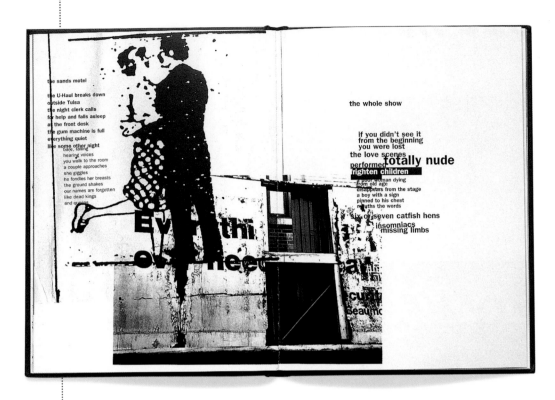

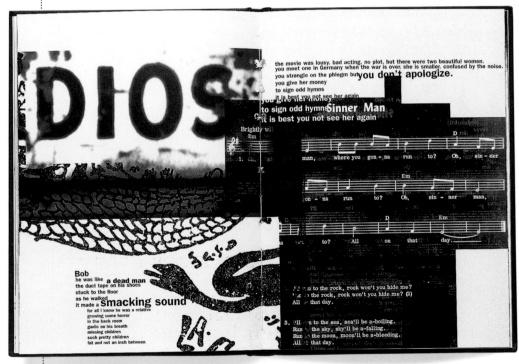

Studio	Inox Design
Designer	Sabrina Elena
Photographer	Stefano Marino
Client/Service	Sector Group/watch makers
Software	FreeHand
Colors	Four-color process plus spot varnish and match silver
Type	FF Rosetta
Special folds and features	Integral cardboard box with die-cut circle and glued-on clear plastic cover, various folds, two Wire-O bindings, special effect with printed acetate and brad

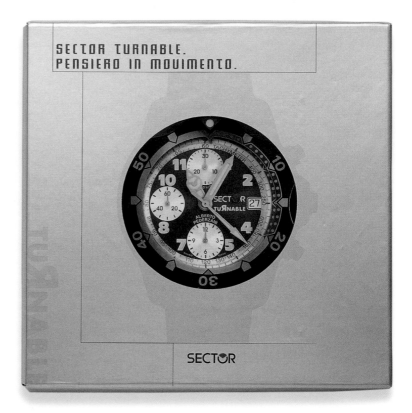

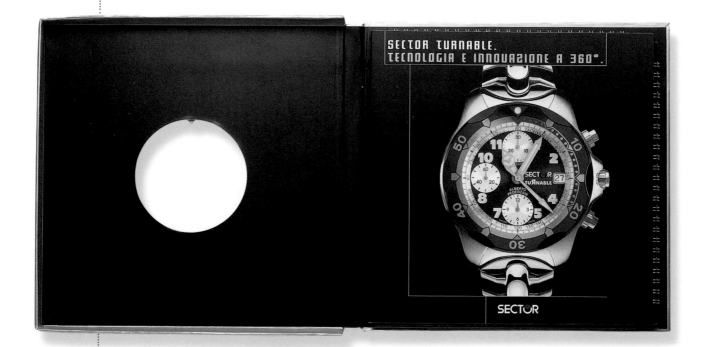

As technical as the product it introduces, this brochure for a precision Italian watch aims to inspire awe for craftsmanship. Each bound into an integral box, two booklets in coated and parchment papers explain the watch's construction and development in minute detail. Hidden at the center of the piece lies its heart: a full-page photo of the watch with a printed acetate face. Thanks to a neat brad fastening, the printed face turns just like the glass lens it represents.

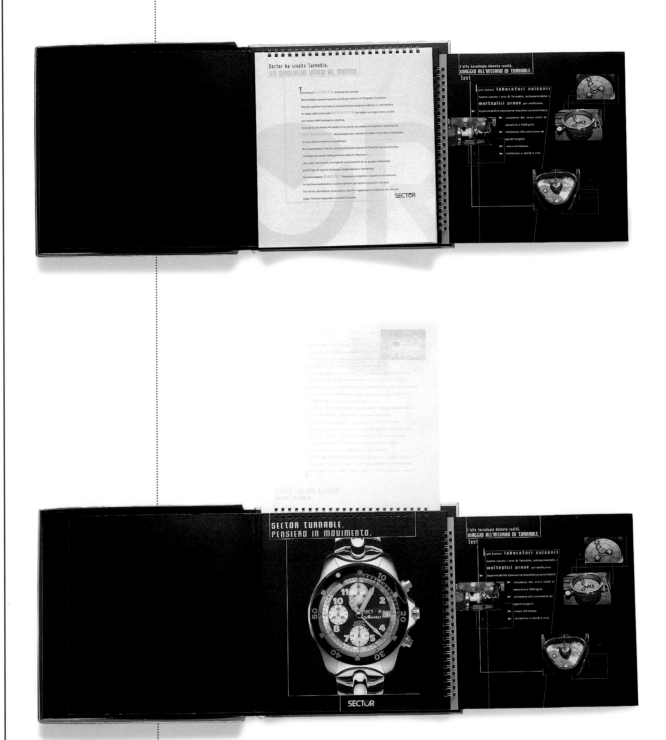

Studio	Particle
Art Directors	Chris Noel, John Foster
Designer	John Foster
Client	Smithsonian Institution Traveling Exhibition Service (SITES)
Software	QuarkXPress, Adobe Photoshop, Adobe Illustrator
Paper	Fox River Confetti
Colors	Two, match
Print Run	100 assembled (50 with sound modules), more unassembled
Cost Per Unit	$6.25 before labor
Type	Democratica, Trade Gothic
Special feature	Light-activated sound module
Special cost-cutting techniques	Manual labor and creative sourcing

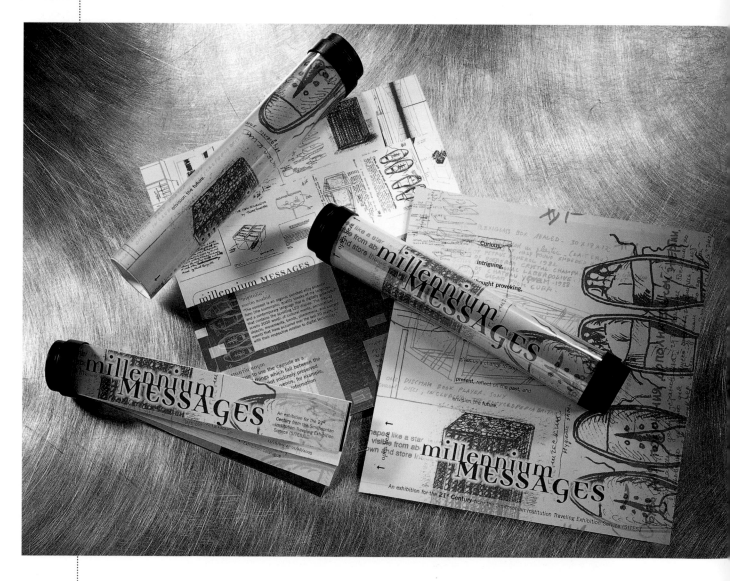

Open this "time capsule," which advertises a traveling exhibit, and you hear *Also Spracht Zarathustra*, the theme from *2001: A Space Odyssey*. *The combination of sound, unusual packaging and unconventional layout prepares the recipient to think about the future. Designer John Foster reports that finishing this job meant washing each tube, working with a quick printer, using sketches because there was no other art and forming "a production line that ran for days and nights, included spouses and left everyone covered in glue and paper bits as we assembled each booklet and capsule." He also says that all the constraints made this one of their most challenging and fun projects.*

Studio	CO:LAB
Art Directors	Richard Hollant, Jim Coon
Designer	Richard Hollant
Producer	Christine Rudolph
Illustrator	Richard Hollant
Photographers	Jim Coon (still lifes), John Soares of John Soares Photography (band shot)
Client/Service	Zigmo Records, Fred Pineau and the Ghost Flames
Software	QuarkXPress, Macromedia FreeHand, Adobe Photoshop
Paper	House sheet
Colors	4-color Process
Print Run	10,000
Cost Per Unit	"Dirt cheap"
Type	Din, Mittle
Special production technique	Match in CD case spine

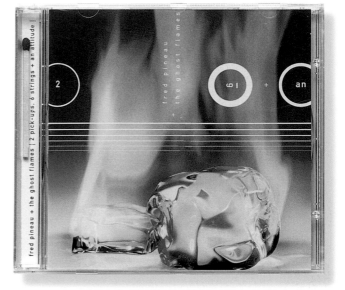

16 | 17

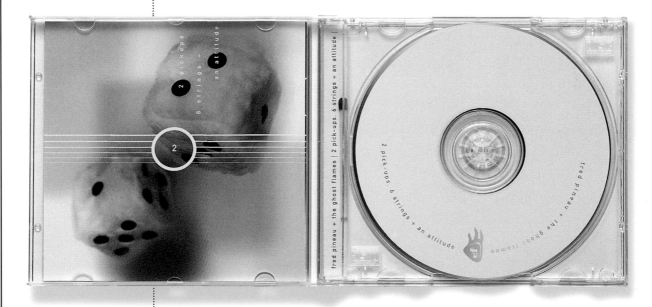

Designer Richard Hollant stored the "silly, haphazard and perfect in its contrivance" effect of old color television in his brain until hired to design this CD. "It was iconographic and heroic and tongue-in-cheek at the same time," he says. "We tried to bring the same feeling to still-life images that fit the band's persona. I particularly liked the kaleidoscopic wackiness of the fuzzy dice. The manufacturers weren't too happy about inserting the matches into the spine of the CD cases, but then again, some-one's always complaining about something."

Studio	Flaunt Magazine/Eric Roinestad Design
Art Directors	Eric Roinestad and Jim Turner ("Flagrant Flowers")
Designer	Eric Roinestad
Editor	Jocelyn Meinster
Photographers	Anthony Mandler (cover), Mikako Koyama (spread)
Client	Flaunt Magazine
Software	Adobe Photoshop, QuarkXPress
Colors	Four-color process plus match green on cover and rose-scented ink on rose
Print Run	90,000
Type	Din Regular Medium (by Albert-Jan Pool), Meta Normal and Black (by Erik Spierkermann)
Special features	Custom die-cut and embossed cover, custom die-cut rose with rose-scented ink to make the rose "pop out and create an air freshener"

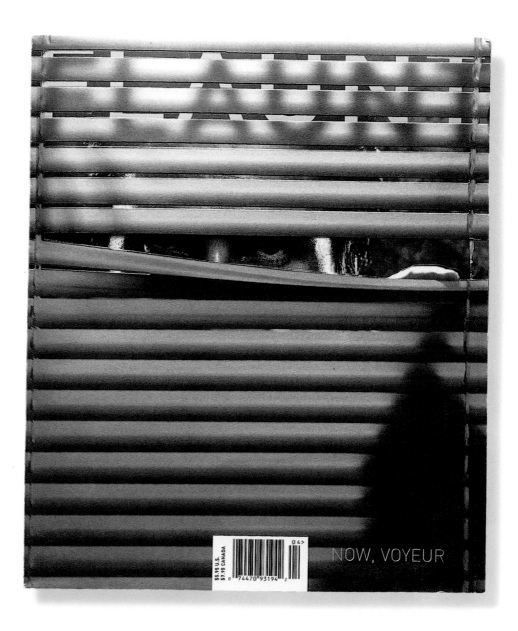

Flaunt hides its celebrity photo shots behind artful, die-cut covers. In this case, actor Christian Bale peers at the reader through half-closed (and embossed) blinds. Articles are given the same playful treatment. Each issue typically contains items for the reader to punch out and construct, such as this air freshener made from a photo of floral designer Micheal George's esoteric work.

FLAUNT

primal scream *james marsden* **elliott smith** *patricia velasquez*
CHRISTIAN BALE

FLAGRANT FLOWERS

written by **Jocelyn Meintser** photographed by **Mikako Koyama**

Michael George is notorious
for taking the petals off flowers only
to delicately wire them back together again.

Punch-N-Sniff Air Freshener.

Studio Flaunt Magazine/Eric Roinestad Design
Art Director Eric Roinestad
Designer Eric Roinestad
Photographer David LaChapelle for Creative Exchange Agency
Client Flaunt Magazine
Software Adobe Illustrator, Adobe Photoshop, QuarkXPress
Colors Four, process
Print Run 90,000
Type Hand-lettered logo, Din Light (by Albert-Jan Pool)

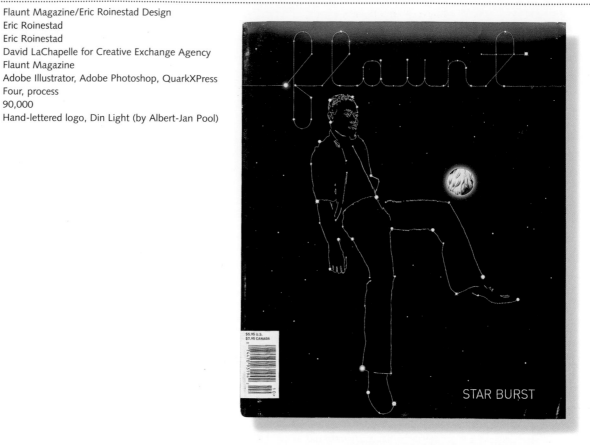

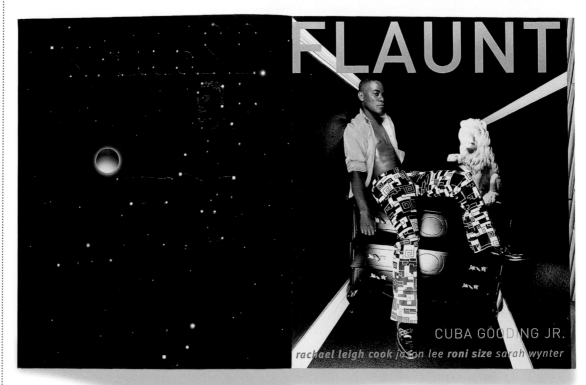

Flaunt Magazine's starry, embossed cover opens to reveal a photo of actor Cuba Gooding, Jr. The die-cut "moon" reveals the fur of the white dog statue. The magazine deliberately flouts the publishing rule of using the cover to reveal what's inside. Instead, Flaunt's readers seem to love guessing.

Studio	Inox Design
Designer	Claudio Gavazzi
Photographer	Lorenzo Scaccini
Client/Service	Racheli & Co./patent and trademark attorneys
Software	Adobe Photoshop, QuarkXPress, Adobe Illustrator
Colors	Three match plus gloss varnish

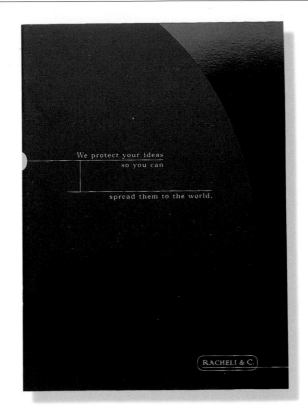

We protect your ideas
so you can

spread them to the world.

RACHELI & C.

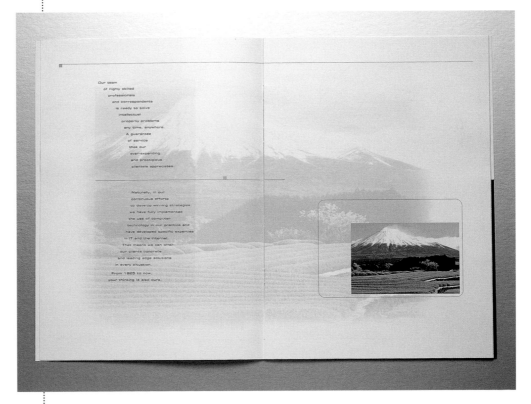

An intriguing combination of photography and type combine to create an elegant brochure for patent and trademark attorneys. Each spread features a small black-and-white photo and a larger version of the same photo ghosted in blue ink. Text set in an arc echoes the stylish cover, which establishes the shape with gloss varnish on a matte coated paper. Inside the piece, spot varnish gives the photos depth and highlights text.

Studio : Peter Schmidt Studios
Colors : Four-color process plus metallic silver
Special features : Lenticular print cover, sewn book binding with ribbon
bookmark, custom cardboard case

Lenticular printing has come a long way since it was used for cereal box prizes and trick postcards.
Here, a glued-on cover creates a background that changes from gray to blue and an identity that
switches between three words and typefaces: Hugo, Boss and Baldessarini. Inside, elegant text and
financial pages contrast with glossy full-page fashion and architecture shots. The report ends with a
four-spread graphic of a race car driving in a glittering silver track, the Boss logo.

Ratios per Share

		EUR	1998 EUR	Change in %
Consolidated net income		8.02	7.07	13
Earnings according to DVFA/SG[1]		8.51	7.14	19
Cash flow		10.37	9.07	14
Dividend	Preferred share	4.07	3.56	14
	Common share	4.00	3.49	15
Dividend incl. tax credit	Preferred share	5.81	5.08	14
	Common share	5.71	4.98	15
Year-end share price	Preferred share	127.00	148.74	(15)
	Common share	118.00	130.15	(9)

[1] Both years' figures calculated on the basis of the 1999 Joint DVFA/SG Recommendation (2nd Edition).

HUGO BOSS Shares Compared to the DAX

	HUGO BOSS Common Share	HUGO BOSS Preferred Share	DAX
Price-earnings ratio 1999[1]	13.9	14.9	30.2
Dividend yield in %[2]	4.8	4.6	1.6
Market capitalization-sales ratio 1999[3]	1.1	1.1	1.3

[1] Share prices at the end of 1999 in relation to earnings in the business year closest to the 1999 calendar year. Earnings forecasts by I/B/E/S. Source: Datastream.
[2] 1999 dividends incl. tax credits in relation to share prices at the end of 1999.
[3] Market capitalization at the end of 1999 in relation to sales figures in the business year closest to the 1999 calendar year. Sales forecasts by I/B/E/S. Source: Datastream.

1999 from the Stakeholders' Perspective

Shareholders

Cautious Valuation of HUGO BOSS Shares

At December 30, 1999, HUGO BOSS preferred shares were listed at 127 Euro and common shares at 118 Euro. Compared with the price at the start of 1999, this reflects a decline of 15% for preferred stock and 9% for common shares. HUGO BOSS shares thus outperformed the CDAX-Textil industry index, but closed below the general German DAX index, which rose 39% over the same period.

There was a general shift in investor demand towards young, fast-paced industries, e.g. telecommunications and internet services. This trend also sparked falls in the share prices of companies displaying powerful growth in other sectors; it affected our shares as well, contributing to the unfavorable developments of 1999. Moreover, the capital market appears to be attaching greater importance to the current burden on results from establishing the BOSS women's collection than to its potential for future gains. During the year 2000 we will continue to report on this project's progress and earnings potential, and remain confident that considerable increases in the share prices can be achieved.

HUGO BOSS Share Ratios

This optimism is based on a comparison between the DAX ratios and key ratios for our shares.
Net earnings per share showed a higher percentage increase than sales, rising from 7.07 Euro to 8.02 Euro. As defined by the DVFA/SG ("German Association of Financial Analysts and Investment Consultants/Schmalenbachgesellschaft") the result per share rose by 19% Euro to 8.51 Euro. Based on the price at December 30, 1999, the price-earnings ratio of HUGO BOSS preferred shares is 14.9 and lower than the DAX's weighted average of 30.2. This reflects both the good earnings position of 1999 and a relatively cautious assessment of our shares. During the year under review, the share price-turnover ratio for the period fell from 1.4 to 1.1, i.e. to a comparatively low level (DAX: 1.3).

Dividend Up Again

For the 1999 business year, the Management Board and Supervisory Board are recommending a dividend of 4.07 Euro per preferred share and 4.00 Euro per common share to the Shareholders Meeting. Shareholders subject to taxation in Germany will also receive the full tax credit of 1.74 Euro and 1.71 Euro respectively. Including the tax credit, the gross dividend yield totals 4.6% per preferred share and 4.8% per common share. This puts the dividend roughly on a par with fixed-interest bearing bonds and renders it clearly superior to the DAX's 1.6%.
The total dividends paid out – a sum of 56 million DEM – correspond to 50% of Group profits. This reflects our earnings-oriented dividend policy which enables shareholders to participate directly in our profits.

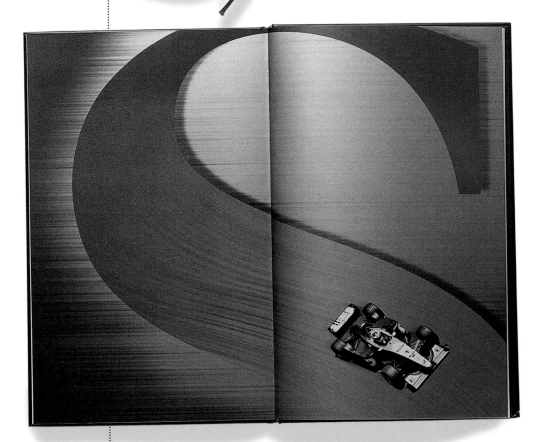

Studio	Studio International
Art Director	Boris Ljubicic
Designers	Studio International
Illustrator	Igor Ljubicic
Photographers	Tomislav Rastic, Boris Ljubicic
Client	International Military Sports Council
Software	3ds Max, Adobe Photoshop, Coreldraw
Paper	Zanders 250 g matte
Colors	Four-color process plus match silver
Print Run	500
Cost Per Unit	$12
Type	Avant Garde, Milton Glaser Stencil, New Times Roman

2. svjetske
vojne igre
2nd Military
World Games
Zagreb 1999
HRVATSKA/CROATIA

PRIRUČNIK

With its five linked rings and five colors, the logo for the 2nd World Military Games was inspired by both the Olympic Games rings and by the Croatian flag. The Graphic Standards Manual's distinct round pages echo the shape of the rings, while distinctive silver metallic accents, stencil page numbers and industrial-style metal bindings add a military touch. The unusual combination of national and international, peaceful and military reflects the unique nature of a military event designed to promote peace.

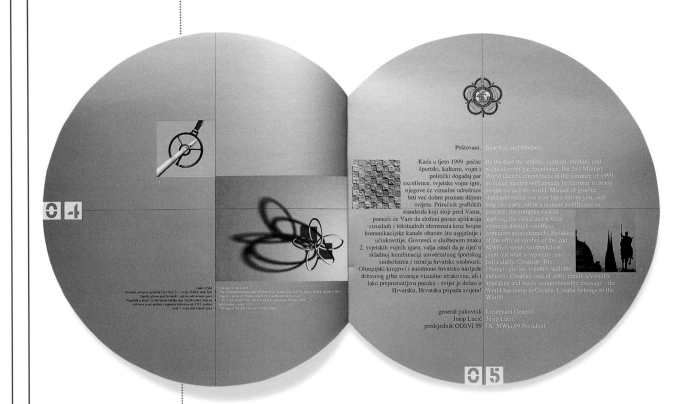

Znak CISM
Hrvatski povijesni grafofofici na crkvi Sv. Lucije, Baška, otok Krk
Zagreb, glavni grad Hrvatske, mjesto održavanja igara
"Pogodak u mrežu", je povijesni viteška igre Šinjska alka, koja se
održava svake godine, u mjestu Inolovora od 1715. godine
Znak 2. svjetskih vojnih igara

1 The sign of the CISM
2 The Croatian historical coat of acroatiana in the church of St. Lucia, Baška, Island of Krk
3 Zagreb, capital of Croatia, where the Games are taking place
4 "Hit at the corner" from the historical knight game Šinjska Alka,
held annually since 1715
5 The sign of the 2nd Military World Games

Poštovani,

Kada u ljeto 1999. počne športski, kulturni, vojni i politički događaj par excellence, svjetske vojne igre, njegove će vizualne odrednice biti već dobro poznate diljem svijeta. Priručnik grafičkih standarda koji stoji pred Vama, pomoći će Vam da složeni posao aplikacija vizualnih i tekstualnih elemenata kroz brojne komunikacijske kanale obavite što uspješnije i učinkovitije. Govoreći o službenom znaku 2. svjetskih vojnih igara, valja istaći da je riječ o skladnoj kombinaciji univerzalnog športskog simbolizma i ozračja hrvatske osobnosti. Olimpijski krugovi i autohtono hrvatsko naslijeđe državnog grba stvaraju vizualno atraktivnu, ali i lako prepoznatljivu poruku - svijet je došao u Hrvatsku, Hrvatska pripada svijetu!

Dear Sirs and Madams,

By the time the athletic, cultural, military and political event par excellence, the 2nd Military World Games, commences in the summer of 1999, its visual identity will already be familiar to many people around the world. Manual of graphic standards which you now have before you, will help you carry out in a manner as efficient as possible, the complex task of applying the visual and textual elements through countless communication channels. Speaking of the official symbol of the 2nd MWG, it seems worthwhile to point out what is typically, and particularly, Croatian. The Olympic circles, together with the authentic Croatian coat of arms, create a visually appealing and easily comprehensible message - the World has come to Croatia, Croatia belongs to the World!

general pukovnik
Josip Lucić
predsjednik OOSVI 99

Lieutenant General,
Josip Lucić
OC MWG 99 President

Studio	Sunspots Creative Inc.
Art Director	Rick Bonelli
Designers	Rick Bonelli, Deena Hartley
Illustrator	Rick Bonelli
Client/Service	Letraset Neilson & Baimbridge/art materials manufacturer
Software	QuarkXPress, Adobe Illustrator
Paper	Neenah Bright White cover, handmade papers
Colors	Four, process
Print Run	350
Cost Per Unit	$1.75
Type	Papyrus, Helvetica Bold
Special production techniques	Die-cut corners, handmade paper glued to covers, objects glued in, drilled hole, ring fastener, attached "tag"
Special type technique	Papyrus was manipulated and reshaped
Special cost-cutting technique	Assembled by designers

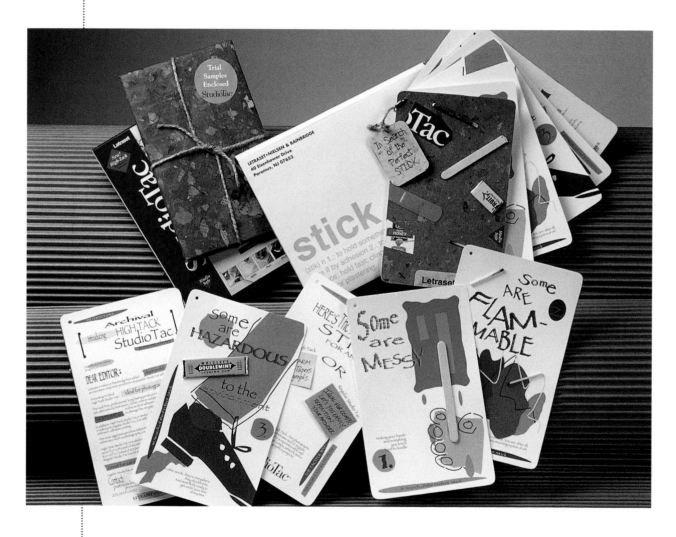

Produced for key retailer accounts and media contacts only, this brochure introducing a new dry adhesive takes a tongue-in-cheek look at "the search for a perfect stick." Lighthearted illustrations and copy feature real objects glued to the sheets with the featured adhesive. According to designer Rick Bonelli, the studio did all handwork, including lighting and blowing out all the matches (four per piece) for safety reasons. "The piece proved to be very time-consuming," Bonelli says, "but resulted in a huge response from the dealers and sales force, and also served as a great showcase for our studio for specialty sales promotions."

Studio	Tayburn Design
Creative Director	Bryan Hook
Senior Designer	Peter McNicol
Client	The Edinburgh Merchant Company Golf Club
Software	QuarkXPress
Paper	GF Smith Colourplan Forest, Elements Bright White
Colors	Two, match
Print Run	200
Special production techniques	Creased hinged, white stitched-binding
Special features	Die-cut cover; die-cut booklet sewn on binding

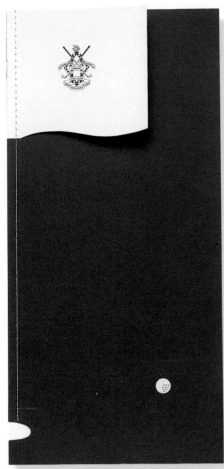

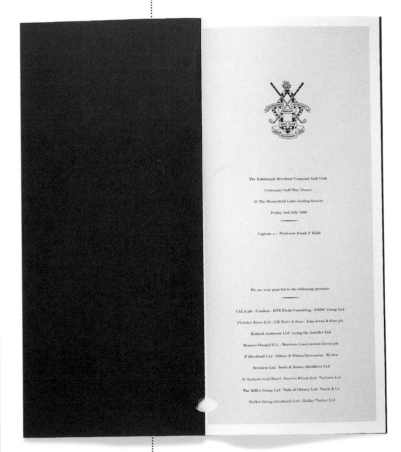

26 | 27

For a dinner celebrating its hundredth anniversary, the Edinburgh Merchant Company Golf Club needed a memorable souvenir menu. Tayburn Design provided this elegant yet playful piece. A die-cut oval becomes a hole on the cardstock cover which doubles as a fairway. A golf ball, printed in white, a stitched "flagpole" border and a sewn-on white booklet with a die-cut waved edge complete the graphic illusion. The flag (booklet) relates the history of the club, allowing a classic, uncluttered layout inside.

Studio	Inox Design
Designers	Alessandro Floridia, Mauro Pastore
Photographer	Stock
Client/Service	Viacom/television, video, retail, books
Software	Macromedia FreeHand
Paper	Various transparent plastics and papers
Colors	Four-color process plus white
Type	Din, Dirty-one
Special production techniques	Spiral binding, solid white printing beneath four-color
Special feature	Plastic "drop" of water glued on cover

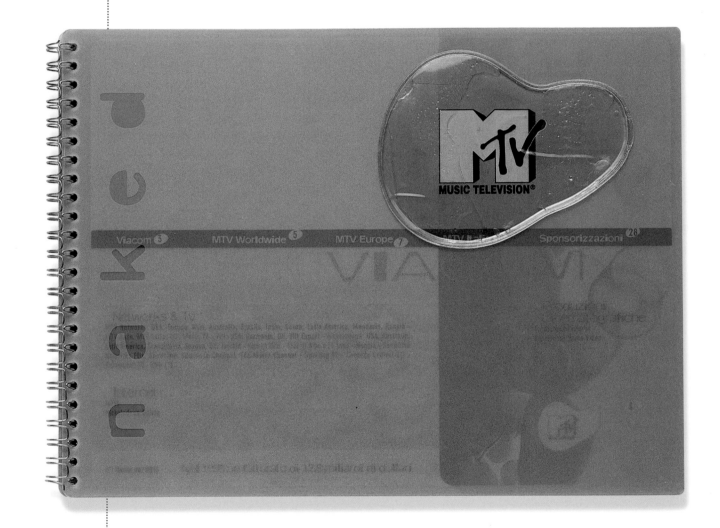

Plastic pages, some more opaque than others, both hide and reveal the pages that follow in this book that markets MTV Europe and MTV Italia. Bright colors contrast with the translucent pages, creating an irreverent look for an eminently practical document. A drop of water-filled plastic glued on the cover becomes a design element used throughout the book. Like MTV itself, the book catches attention through titillation but sells hard the old-fashioned way.

Studio	Lewis Moberly
Art Director	Mary Lewis
Designers	David Jones, Bryan Clark
Illustrators	Bryan Clark, Steven Sayers
Copywriters	Martin Firrell, William Maughan
Client/Service	Millward Brown Precis Limited/media analysis software
Software	Adobe Illustrator
Paper	KeayKolour Guardsmen Red 400 gsm (cover), Neptune Unique 250 gsm, red film
Colors	Three match plus red foil
Print Run	2,000
Cost Per Unit	£5.67
Type	Minion Regular, Italic and Semi Bold
Special production techniques	Wire-O binding, embossed cover, red foil, interleaved red film
Special fold	Canadian fold to cover binding

WHAT CAN PRECIS DO FOR YOU?

THE INTELLIGENCE will tell you where you are, how you're perceived and the extent of your media favour. Precis will give you a measure of your communications effectiveness.

With this insight you can construct benchmarks. Gauge targets. Improve communications. Take an independent, objective view of your media position.

All of this in direct relation to your competitors.

Red film interleaved between the pages makes this brochure spring to life. Bold type and big margins make the technical data seem friendly and easy to understand. Words and graphics printed in red or white are invisible when viewed through the red film but appear as soon as the page is turned - a surprising effect that hooks the reader until the last page.

International Focus

Precis acknowledges no geographical limits.

A global network of offices and partners monitors international coverage, opinion, and its implications for your global business.

With multilingual analysis and reports, together, we have the world covered.

"Drawing on worldwide coverage, Precis offers a coherent analysis of global campaigns and issues which have an impact on our core businesses. Precis has become a critical planning tool for us."

PHILIP ANGELL DIRECTOR CORPORATE COMMUNICATIONS MONSANTO

Studio | Aufuldish & Warinner
Art Director | Bob Aufuldish
Designer | Bob Aufuldish
Client/Service | CCAC Institute/exhibitions, programs, art gallery
Software | Adobe Illustrator
Paper | Creator Silk Text 100#
Colors | Two, match
Type | Akzidenz Grotesk

ccac institute presents_an exhibition in san francisco & oakland

rooms_for_listening

san francisco exhibition dates
: september 5 through october 14, 2000
opening reception: friday, september 8, 8 to 11 pm_kent and vicki logan galleries
ccac montgomery campus_1111 eighth street (at 16th and wisconsin streets)_san francisco
san francisco installations
thom faulders/beige design: mute room_involving systems/meso: mutable muzzy musics_
toshio iwai: composition on the table_leo villareal: sound box
performances
joshua kit clayton_atom heart_matthew herbert/radioboy_brandon labelle_
loren chasse/eleanor harwood_blectum from blechdom
oakland exhibition dates
: september 27 through october 28, 2000
opening reception/performances: wednesday, september 27, 7 to 10 pm_oliver art center
ccac oakland campus_5212 broadway (at college avenue)_oakland
oakland installations
toshiya tsunoda: monitor units for solid vibration/oliver art center_john hudak: facade

This simple two-color poster that advertises a series of musical performances also doubled as a mailing. "Much of the music is sample and beat-oriented," says art director Bob Aufuldish. "The series of slashes suggest four-four time. There are 32 four-beat measures depicted." The underscoring in the title, he adds, "refers to the musicians' practice of naming songs in computer file format (with the underscore replacing a space)."

Studio	Mastandrea Design, Inc.
Art Director	MaryAnne Mastandrea
Designer	MaryAnne Mastandrea
Client/Service	Imagine Media/computer and video games network
Software	QuarkXPress, Adobe Illustrator, Adobe Photoshop
Paper	.017 mil Lenticular vinyl, honeycomb pattern (cover), 120# McCoy Silk Cover (folder)
Colors	Three, match (cover), four-color process plus one match and flood aqueous (folder)
Print Run	1,500
Cost Per Unit	$10.75
Type	Template Gothic
Special features	Lenticular vinyl cover, spiral binding
Special production techniques	Screen-printed cover, double hit of black on folder

32|33

A distinctive patterned plastic sets the tone for this media kit. Its eye-popping honeycomb pattern reveals the bright colors of the video game graphics reproduced beneath. "This piece needed to stand out, and it had to be cutting edge for the entertainment/video industry," says art director MaryAnne Mastandrea. "Covering the images with holographic plastic created intrigue and gave it a 3-D effect."

Studio	Dee&Alison Graphic, Inc.
Art Director	Kohshun Yanagida
Designer	Kohshun Yanagida
Client/Service	Gin Dining Co., Ltd./restauranteurs
Software	Adobe Illustrator, KPT Warp Frame
Paper	Various including cardboard, ropple board, bubble wrap and handmade Italian papers
Type	Franklin Gothic, Zapf Chancery, Goudy Old Style, various Japanese fonts
Special cost-cutting technique	"Making it by myself, because I make it cheaper."

Designer Kohshun Yanagida created all the collateral for Chop&Stick, a Tokyo wine bar, using bold materials. In design-conscious Japan, a combination of classic simplicity, traditional Japanese crafts, a dash of English and unusual materials attract young professionals. Corrugated cardboard, topped with bubble wrap or wrapped in colored corrugated board, provides the design basis. Chopsticks— rustic wood or elegantly shellacked—hold the pieces together with red elastic cords. Origami-folded grand opening brochures and a press release sewn into a rustic, Italian paper jacket complete the intriguing package. When no printer could make them, says the designer, "I made them myself."

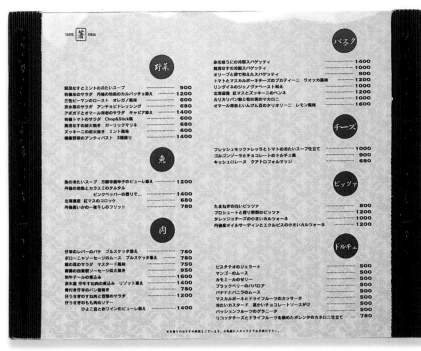

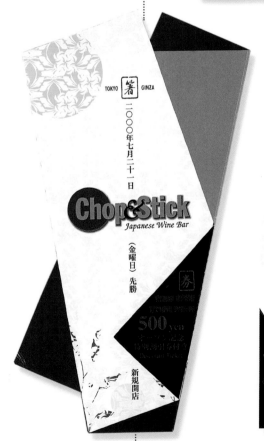

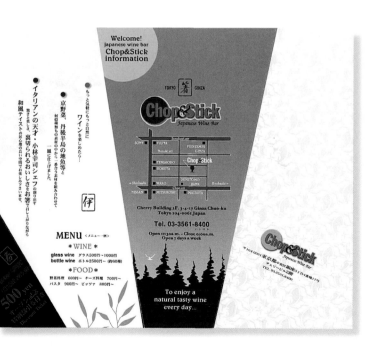

Studio	StudioNorth
Designer	Erik Peterson
Photographer	Patti Monaghen
Copywriter	LaDonna Willems
Client	AXIS, a ministry of Willow Creek Community Church
Software	Adobe Photoshop, Adobe Illustrator, QuarkXPress
Paper	Champion Benefit Butter 70 lb. text
Colors	Four, process
Print Run	9,000
Cost Per Unit	$0.50
Type	Caslon, various
Special type technique	"I don't want to give away any secrets here, but basically I combined multiple typefaces to create a new one for all the heads."
Special features	Folds into twelve mini pages or out into one small poster

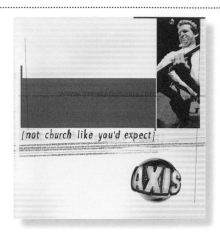

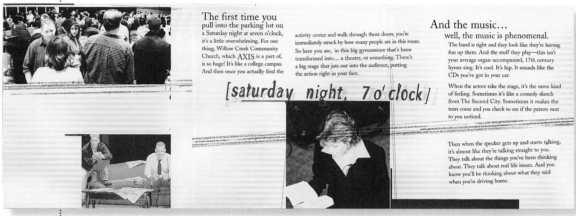

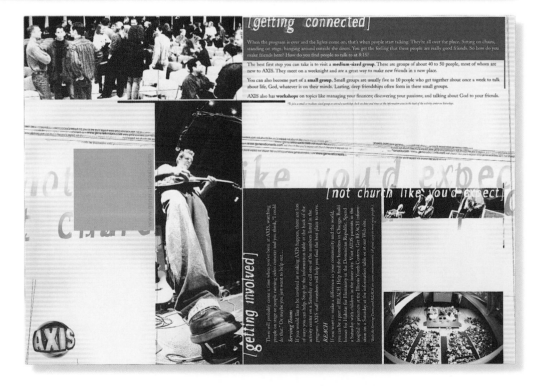

Like many contemporary ministries for the "unchurched," AXIS takes a nontraditional approach to religion. This brochure communicates its attitude and friendliness through design, using type and CD-case-style photography. "In trying to reach an audience of twenty-somethings," says the designer, "I felt it was important to contrast a more conservative typeface with something broken or distressed."

Studio	Sunspots Creative
Art Director	Rick Bonelli
Designers	Rick Bonelli, Deena Hartley
Client/Service	Premium Color Graphics/digital pre-press, film separation and printing
Software	QuarkXPress, Adobe Illustrator, Adobe Photoshop
Paper	JOB Parilux 110# Cover, two-tone cream and white, litho film, scrap film
Colors	Four-color process plus varnish
Print Run	5,000
Cost Per Unit	$1.25
Type	Claude Sans, Frutiger, Leawood, John Doe
Special production techniques	Foil stamping, wire binding
Cost-cutting techniques	Printing on leftover litho film and using waste film for graphics added unusual elements at no extra cost.

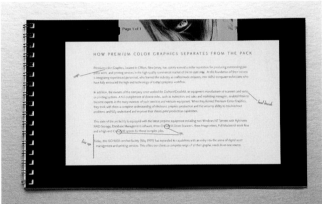

36 | 37

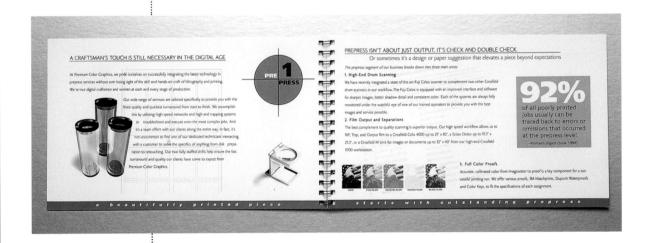

Designed to showcase the client's high-tech equipment and Old-World craftsmanship, the brochure simulates the printing process from the "pica ruler" printed on litho film and bound to the front cover to the press check printed on the last page. Foil-stamped covers add an elegant, expensive look. Scrap film sheets cut to size and bound in make every piece different. "A separate white sheet with 5 percent yellow tint was printed to make a blueline sheet, then glued to the film for a unique effect," says art director Rick Bonelli.

Studio	Iridium marketing + design
Creative Directors	Jean-Luc Denat, Mario L'Écuyer
Art Director	Mario L'Écuyer
Designer	Mario L'Écuyer
Illustrator	Lucero Sãnchez
Photographer	Headlight Innovative Imagery
Artifacts construction	Etienne Bessette, Jacob Bryce
Client/Service	Rolland, Inc./paper manufacturer
Software	QuarkXPress, Adobe Photoshop, Adobe Illustrator
Paper	Rolland Motif, screen, pure white 70 lb. text and 90 lb. cover
Colors	Four-color process plus five match
Print Run	5,000
Cost Per Unit	$4 Canadian
Type	Emigre Arbitrary Sans, Emigre Keedy Sans, Calvino Hand (by Elliott Peter Earls), Vitrina (by Pablo Medina), Interstate, Barbera (by T[26])
Special production techniques	Drilled holes, die-cuts and fold-over cover; stapled binding; French-folded pages

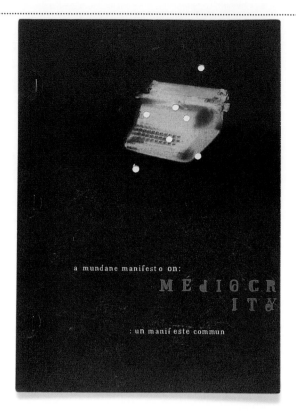

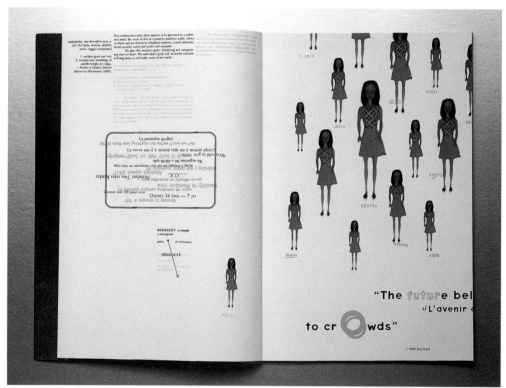

Type design does double duty here, because the extensive copy has to communicate in both English and French. Sometimes the two texts sit fairly calmly side by side, sometimes they interweave and sometimes both pieces do something entirely different. "Binding the piece was interesting," says art director Mario L'Écuyer. "The design and construction of the different 'artifacts' used for photos was also a real challenge. Language was touchy . . . the client requested equal weight for both French and English. I obeyed these basic type principles: hierarchy, balance, contrast and tension."

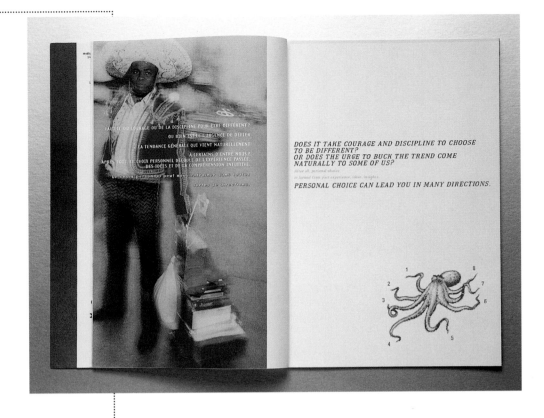

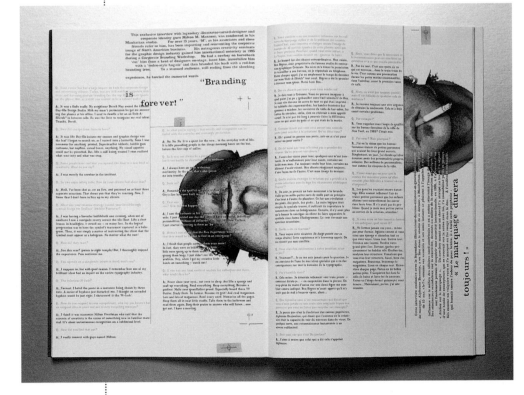

Studio	Louey/Rubino Design Group Inc.
Art Director	Robert Louey
Designers	Robert Louey, Alex Chao, Anya Mueller
Photographers	Eric Tucker; Jamey Stillings; Everard Williams, Jr.; Lisa Metzger, Neal Brown, Ann Elliott Cutting, Hugh Kretschmer
Client	Self
Software	Adobe Illustrator, Adobe Photoshop, QuarkXPress
Paper	Gilbert Esse 80 lb. Texture Text, Gilbert Oxford 80 lb. text and cover, Mead 100 lb. Signature Suede Text
Colors	Eight, match and process
Print Run	12,000
Type	Bembo, Helvetica, Aachen, Trade Gothic, Bodoni, Century Schoolbook, Janson, Achen
Special production techniques	Embossing, debossing, spot varnish
Special fold	Calendar pages are French-folded
Special cost-cutting technique	Free

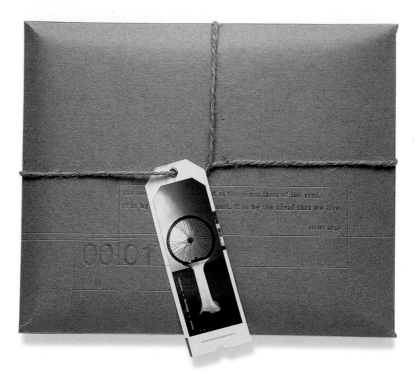

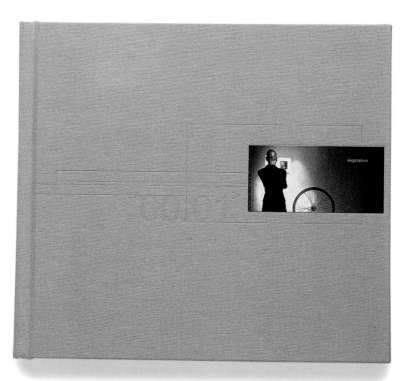

This millennium calendar, created as a promotional piece by the designers, a writer, a group of photographers, a paper company and a printer, is a calendar in name only. The spare calendar pages, printed on uncoated paper, are almost an afterthought in this imaginative collection of thoughts, photographs, illustrations and type treatments. Mailed in an embossed cardboard envelope, the calendar was tied together with twine for a twist on traditional holiday wrappings.

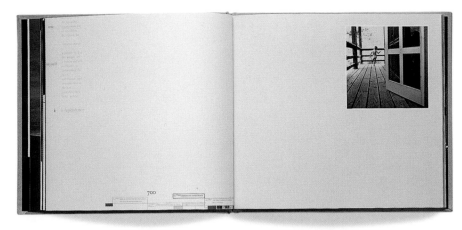

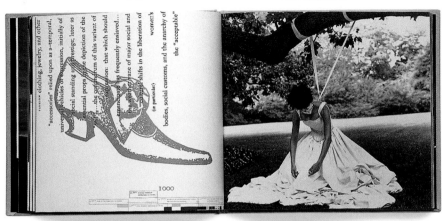

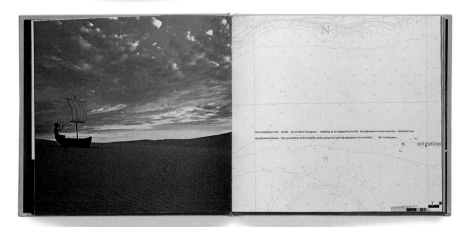

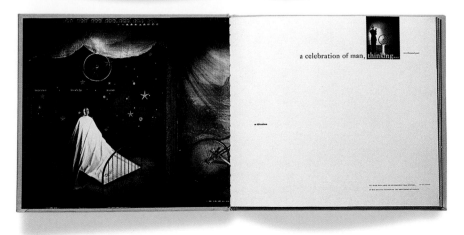

STUDIO NORTH

BERNHARDT FUDYMA

NIEHINGER ROHSIEPE

GEE + CHUNG

D ZONE SHADE

MARIO AURELIO

SOUND TRANSIT

BK DESIGN

CURRY DESIGN

IE DESIGN

MATTHIAS KARIM ARICE

CO:LAB

FIREHOUSE 101

MARGO CHASE DESIGN

Y DESIGN

BOELTS

PEG FAIMON DESIGN

GEORGE TSCHERNY

WEST & VAUGHAN

PARTICLE

ERWIN ZINGER

AUFULDISH & WARINNER

...sh, aka fontBoy, will present a multimedia lecture on...

FFFFFFFFFFFFFFFFFFF Friday yyyyyyy June 30, 200...

ssssssseeeeeevvvvveeeeeennnnnn 7-8 eeeeeeiiiiii...

uuuuuuuuuuuuuuuuuuuuuuuuuuuuuuuuuuuu...

jaarverslag

Are

formation call: 537.2286 or email sll@hawaii.rr.com

chapter 2 **TYPE**

1 47 49 00 64 51 56 648 3435 87 5 768 71 175 845 35 6 43 1

The written word is more difficult to use and interpret than we generally acknowledge. Try to read a paragraph in another language, and you realize how much we rely on familiar associations to help interpret a word's dictionary meaning. Try to puzzle out that ambiguous e-mail that came this morning, and you understand how much we rely on the human voice, facial expression and gestures to communicate meaning.

Type designers have long understood that printed letters can simulate speech, giving a printed sentence the correct emphasis and communicating a tone. Today, computer typesetting has made both traditional letterforms and bizarre avant garde variants easier to use and manipulate. Now it's easier than ever to use type just the way you want to.

Unfortunately, it's also easier to use type badly. The following pages show type used just the way it should be, to communicate the right message the right way.

Studio	Maddock/Douglas, Inc.
Art Director	Maddock Douglas team
Designer	Maddock Douglas team
Client	Self
Software	Adobe Photoshop, QuarkXPress
Paper	French Speckletone Natural Cover
Colors	Two, match
Print Run	250 each

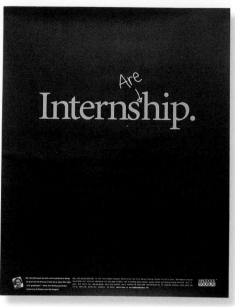

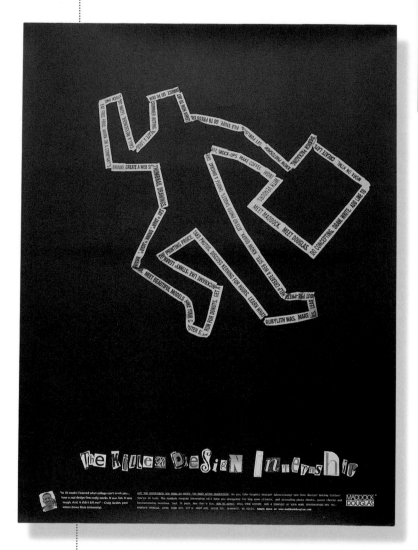

The typewriter-style text ghosted out of the bottom of these posters may be tiny, but no would-be design intern could resist reading it after seeing these hung on their classroom walls. Attention-grabbing graphics and type float on a dense black background, practically begging for a closer look.

Studio	Erwin Zinger graphic design
Art Director	Erwin Zinger
Designer	Erwin Zinger
Photographer	Stock or provided
Client/Service	Uitgeverij Rotterdam and Free Record Shop/publisher and leading retail chain in the Netherlands, Belgium, Luxembourg, Finland and Norway
Software	QuarkXPress, Adobe Illustrator, Adobe Photoshop
Colors	Four-color process
Print Run	100,000
Type	Magneto Bold by Leslie Cabarga (logo, headlines); Aura, by Ian Ronen (introductions, some headlines); Zurich (body)
Special type technique	Magneto's alternate characters allowed the designer to alter the look without altering the type.

Designed for a popular European record-store chain, this full-color magazine has the deliberate low-tech look of an independent publication but features all main-stream (and nearly all American) movies, albums and video games. The layout is neat, but not too neat, featuring contemporary type-faces and copy that goes margin to margin as if assembled by amateurs. Its design hides its corporate origins, as it successfully markets corporate products.

Studio	Tayburn Design
Creative Director	Bryan Hook
Designer	Peter McNicol
Client/Service	Edinburgh International Festival/music and art festival
Software	QuarkXPress
Paper	White Satin board
Colors	Two, match
Print Run	400
Special features	Two concertina folds; two die-cuts

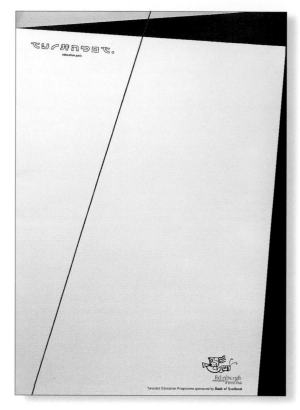

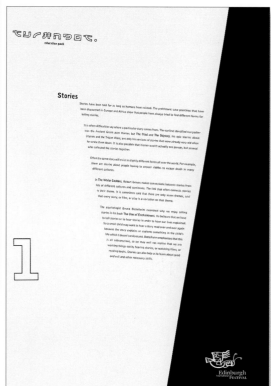

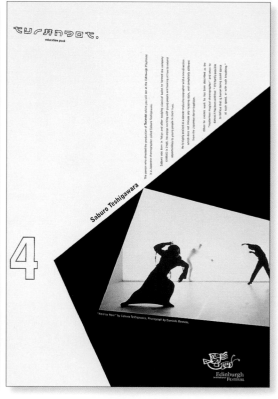

Die-cut triangles, angled edges, slanted wedges of black and gray, and type arranged in jagged blocks give this otherwise traditional piece a frenetic look. The main piece, with its angled top and far right edge, sets the stage. Two more pages, printed on traditional rectangular sheets but with die-cut triangles in two places, continue the irregular look even as they break up the educational information into neat, easy-to-read pieces. A red elastic tie adds a shot of bold color.

Studio	Aufuldish & Warinner
Art Director	Bob Aufuldish
Designer	Bob Aufuldish
Photographer	Bob Aufuldish
Client	AIGA Honolulu
Software	Adobe Photoshop, QuarkXPress
Paper	House sheet
Colors	Two, match
Type	Armature, Baufy, New Clear Era, Punctual, RoarShock, Whiplash (all by Bob Aufuldish for fontBoy), Viscosity (by Kathy Warinner and Bob Aufuldish for fontBoy)

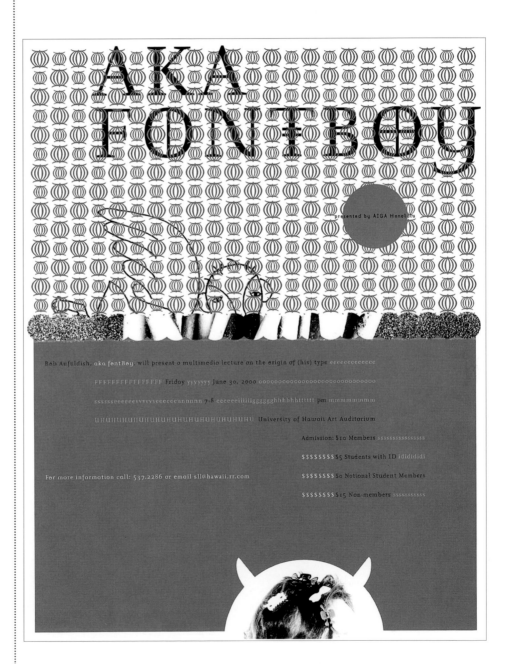

Type stars in this announcement for a talk by Bob Aufuldish, a.k.a fontBoy. Letters and dingbats from the fontBoy collection make up the design created by Aufuldish & Warinner - who happen to be the brains behind the fonts in the first place.

Studio	Erwin Zinger graphic design
Art Director	Erwin Zinger
Designer	Erwin Zinger
Photographer	Marinus Brink
Client/Service	Waterlaboratorium Noord/water laboratory
Software	QuarkXPress, Adobe Illustrator, Adobe Photoshop
Paper	Only Natural Algae 190 gsm (cover), Butterfly nut brown 120 gsm (inside cover), Butterfly soft orange 120 gsm (text)
Colors	Four, process (title pages and graphics); match black (text); two, match (cover); match silver (inside cover)
Print Run	200
Type	Embassy (headings), Linotype (subheads), Serpentine (text)
Special production techniques	Stitched cover with linen binding, paper cover glued on over fabric

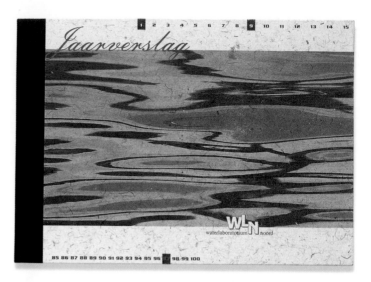

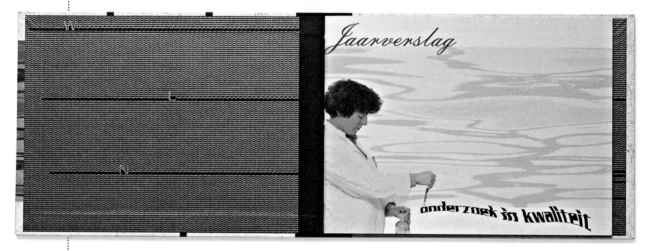

Beautifully bound, this annual report for a water-testing laboratory looks more like book of poetry than an official document. The two-color cover is printed on handmade paper that includes algae as well as pulp. Waving lines of silver ink on the inside covers mimic the flow of water, an element repeated more explicitly on the year-in-review and financial information introduction pages, which feature photography and muted four-color printing.

Studio	Particle
Art Directors	Chris Noel, John Foster
Designer	John Foster
Illustrators	John Foster, Big Cheese
Client	Art Directors Club of Metropolitan Washington
Software	QuarkXPress, Adobe Photoshop, Adobe Illustrator
Paper	Fox River Starwhite Tiara Smooth
Colors	Four-color process
Print Run	2,000
Cost Per Unit	Donated
Type	Trade Gothic, Adobe Garamond, Base Nine
Special production techniques	Overprinting and splitting plates
Special type techniques	Perspective and pixilaton on Base Nine, "ruining the integrity of a great font in the name of design"

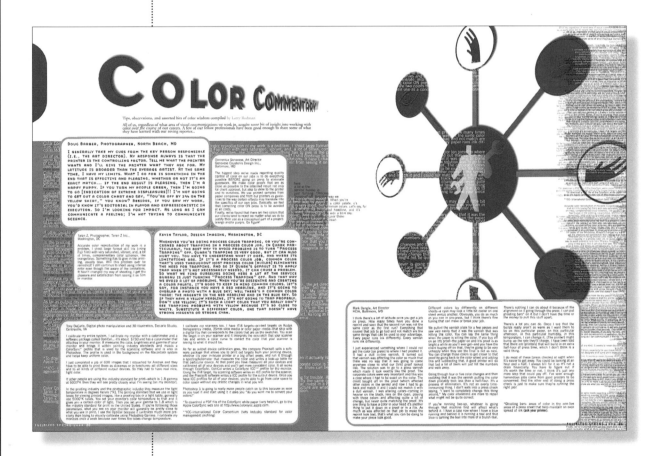

48|49

Design and printing tricks make a series of small comments look like a debate in this spread. The central image was created by Big Cheese for an earlier job but was never used. Designer John Foster drew new icons and added the perspective. Overprinting creates the feeling of a room crowded with people, all of them talking at once. "The printer donated the printing in exchange for foregoing color proofs," Foster explains. "We probably would not have attempted tricks like splitting and overprinting the plates if we had not had past experience doing it, but the printer's confidence paid off."

Studio	West & Vaughan
Creative Director	Robert Shaw West
Art Director	Shawn Brown
Designer	Shawn Brown
Client/Service	Herpes Advice Center/health care
Software	Adobe Illustrator
Colors	Two, match
Print Run	10,000
Cost Per Unit	$0.50
Type	Helvetica
Special production technique	Spot varnish

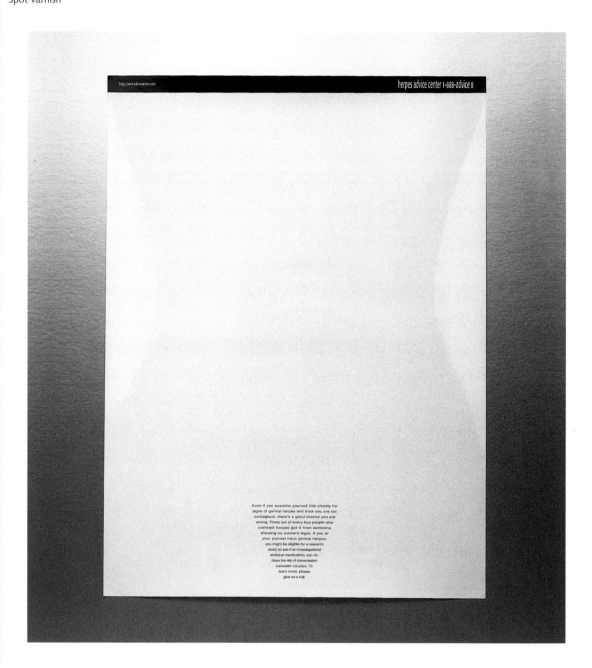

Type says it all in this design, which was used both for posters and alternative newpaper ads. White space frames the tiny text, which invites people close, tells them they can have herpes without know-ing it and lets them know how they can be part of a drug study. Dull varnish in the shape of a woman's body helps communicate the illusion. "The funny part is that this is one of the most difficult typesetting jobs we've done," says creative director Robert Shaw West. "You'd be surprised how many opinions people have on such a simple shape."

Studio | George Tscherny, Inc.
Creative Director | Silas H. Rhodes
Designer | George Tscherny
Assistant Designer | Matthew Cocco
Client | School of Visual Arts
Software | Adobe Photoshop, Adobe Illustrator, QuarkXPress
Paper | Fraser 50 lb. Torchglow Cover
Colors | Two match
Print Run | 5,000
Type | Various

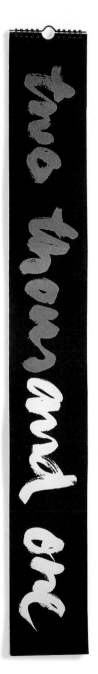

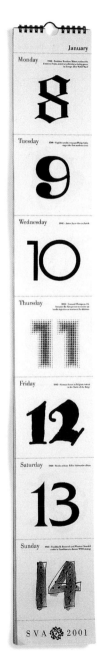
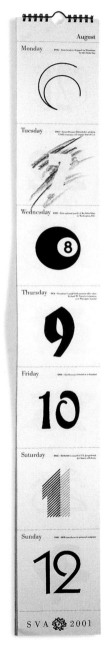

50 | 51

Every date on this Asian-style wall calendar is in a different typeface or handwritten number. "I work with a very limited selection of typefaces . . . except when I don't," says designer George Tscherny. "Here, type as image is the point, and the challenge was to find or create as many forms as possible. Making use of the found object in art or typography requires unconventional vision . . . scavenger eyes."

Studio	Peg Faimon Design
Art Director	Peg Faimon
Designer	Peg Faimon
Photographers	Applied Technologies, Miami University; Ivan Pinkava (cover)
Client	Miami University School of Fine Arts
Software	QuarkXPress, Adobe Photoshop
Colors	Four, process (cover); match black (text)
Print Run	9,000
Cost Per Unit	$1
Type	Adobe Caslon, Gill Sans

An intriguing color cover introduces this alumni magazine for a fine arts program. Finely reproduced, this deliberately ambiguous close-up shot looks like a shot of a machine. Opening the cover for a full-length shot reveals that it's a collaborative sculpture. Unusually placed photographs, drawings and type enliven the black-and-white inner pages, while ghosted images add the look of a second color.

Studio	West & Vaughan
Creative Director	Robert Shaw West
Art Director	Shawn Brown
Designer	Shawn Brown
Photographer	Photonica
Client/Service	NC Warn/activist group
Software	Adobe Photoshop
Colors	Four, process
Type	OCR
Special type technique	"All the type was imported into Adobe Photoshop and filtered over and over again to create a sort of nuclear X-ray look."

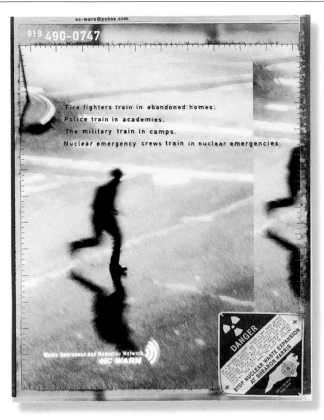

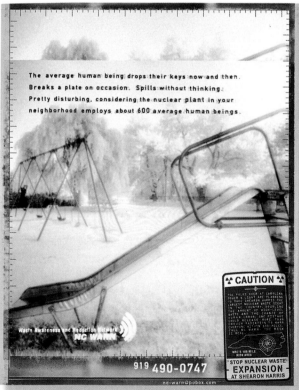

52|53

This series of ads for an activist group "passionately devoted" to stopping expansion of a nuclear power plant uses blurred photos to get the viewer's attention, following up with hard-hitting copy. "Belying North Carolina's wholesome and unspoiled self-perception, current Nuclear Regulatory Commission plans would turn the state into the country's largest nuclear waste site," says creative director Robert Shaw West. "The strange thing is . . . ask anyone around these parts, and they have no idea."

Studio	Boelts Bros. Associates
Art Directors	Jackson Boelts, Eric Boelts, Kerry Stratford
Designers	Jackson Boelts, Eric Boelts, Kerry Stratford, Elicia Knifin, Adanta
Illustrators	Jackson Boelts, Eric Boelts, Kerry Stratford
Photographer	Balfour Walker
Client	Self
Software	Macromedia FreeHand
Paper	Fraser Pegasus
Colors	Four, process; match red wrap
Print Run	5,000
Type	Clear Cut Caps, 2Rebels, Frutiger
Special production techniques	Perfect-bound book, embossed corrugated board mailer
Special feature	Vellum wrap with custom seal

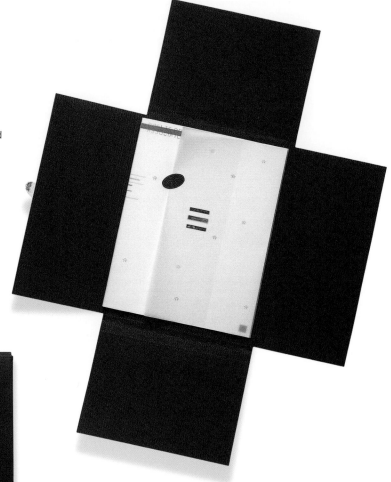

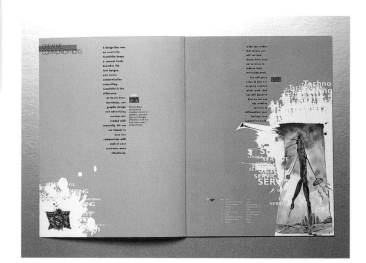

From its white cover, broken by little more than slivers of cartoonish monster illustrations, to its horror movie-inspired illustrations, this self-promo assures prospective clients that the company's "creative vision is skewed, unusual and terrifyingly effective." Simple, narrow columns of type add a reassuring voice to the frenetic combination of graphics.

Studio	Y Design
Art Director	Martin Ogoltier
Designer	Martin Ogoltier
Client/Service	The Apartment/retail
Software	Adobe Illustrator
Colors	Two-over-two, match
Print Run	1,000
Cost Per Unit	$6.25 before labor
Type	Akzidenz Groetsk
Special feature	Metallic blue ink

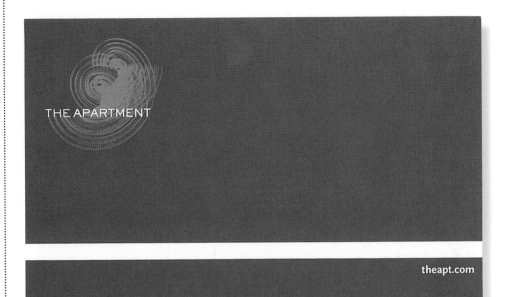

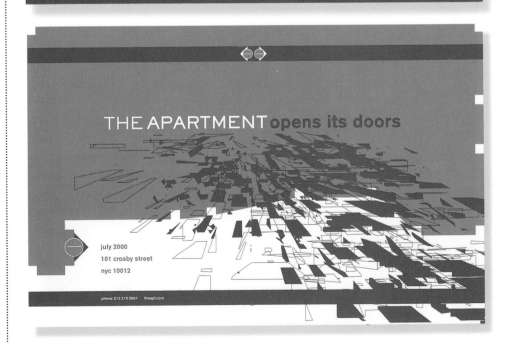

This invitation/ticket to a "housewarming" for an innovative furniture store accomplishes a lot with a little. Three distinctive colors include a metallic blue. White space makes a fourth color. Type reveals just enough about the event to spark curiosity. The inspiration, according to art director Martin Ogoltier, was "an architectural floor plan and abstractions that represent the young designers whose furniture and objects the store sells."

Studio	Erwin Zinger Graphic Design
Art Director	Erwin Zinger
Designer	Erwin Zinger
Photography	Stock
Client	Self
Software	QuarkXPress, Adobe Illustrator, Adobe Photoshop
Paper	gsm Greyboard (cover); 250 gsm Erasmus (text), 120 gsm Erasmus (reply cards)
Colors	Three, match
Print Run	1,000
Cost Per Unit	$1.70
Special feature	Oversize cardboard cover that doubles as an envelope

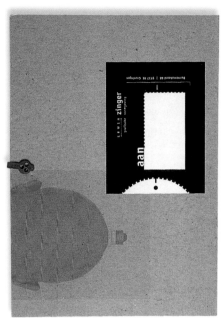

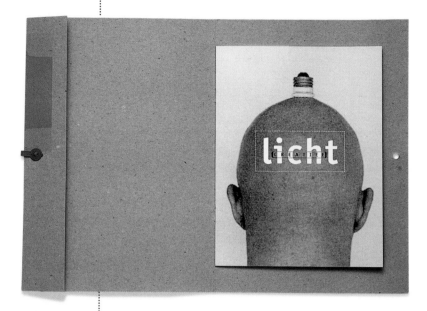

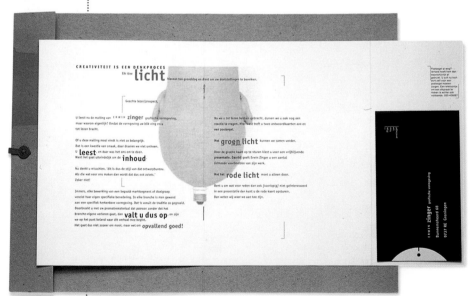

A stock photo of a bald head provided the inspiration for this self-promo. Clever layout and a grey cardboard cover that doubles as a mailing envelope make this simple three-color printing job look more expensive. Reproducing the image as a line screen adds a distinctive look for no cost. The orange plastic fastener, a kind of envelope lock used frequently in the Netherlands, matches the orange ink and becomes another design element.

Studio | Margo Chase Design Group
Art Director | Jonathan Sample
Designer | Jonathan Sample
Client/Service | Cognito Films/commerical production company
Software | QuarkXPress, Adobe Photoshop, Adobe Illustrator
Colors | Four, process
Type | Microgramma

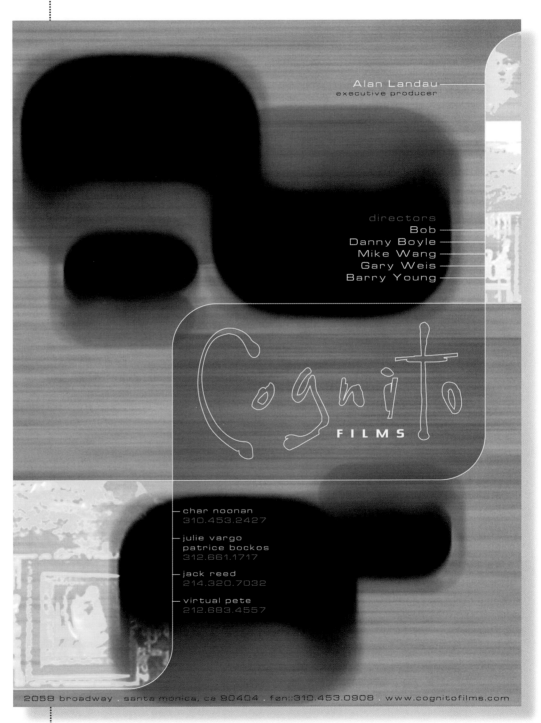

Type stars in this ad for a film company. Enigmatic black characters, oversized and blurred, grab the eye while a bright orange and yellow background holds attention. Much of the important information is ghosted out of the black, making it readable and easy to find.

Studio	West & Vaughan
Art Director	Rob Baird
Designers	Charles S. Anderson, Jason Schulte
Illustrator	CSA Archive
Client/Service	Biscuitville/Retail Fast Food
Software	QuarkXPress, Adobe Illustrator
Colors	Four, process
Type	Trade Gothic, Berthold
Special type technique	All type was set in QuarkXPress, then enlarged on a photocopier to six times its original size and assembled as final artwork.

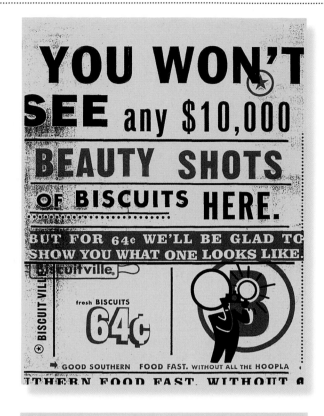

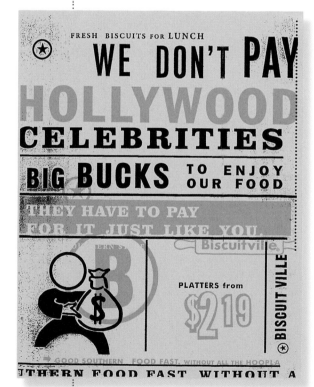

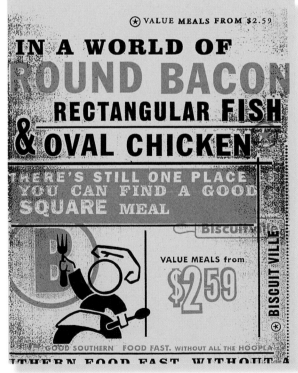

Every dish at Biscuitville, a regional fast-food chain, features home-cooked biscuits. Advertising has to reveal what makes Biscuitville unique—and it has to do it on a minuscule budget. "This restaurant had nothing," says creative director Robert Shaw West. "No Happy Meals, no neon signs, no juicy product photograpy, no celebrity endorsements." The pieces, deliberately low-tech, use that "nothing" to reveal the client's essential nature: "They care about the food, not about fancy marketing."

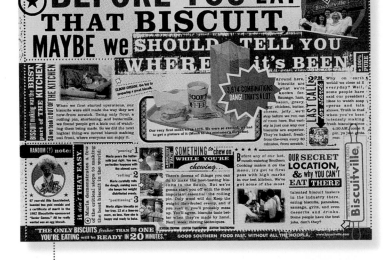

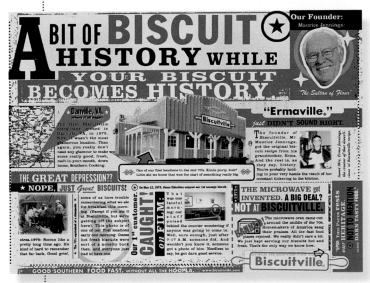

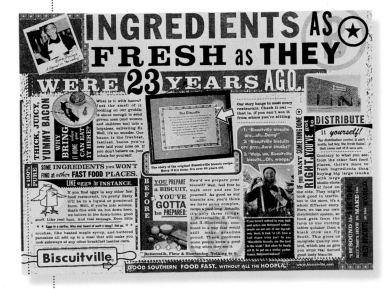

Studio	Firehouse 101 Art + Design
Art Director	Kirk Richard Smith
Designers	Kirk Richard Smith, Brad Egnor
Illustrators	Michiko Stehrenberger, Keith Novicki, Marcelle Gilkerson
Photographers	Chas Krider, Will Shively, Stephen Webster
Copywriter	George Felton
Client	Columbus Society of Communicating Arts
Software	Macromedia FreeHand, Adobe Photoshop
Paper	Sterling
Colors	Four-color process plus match silver and dull varnish
Print Run	2,500
Type	Helvetica, Base (by Emigre), Times Roman, Rubber Stamps

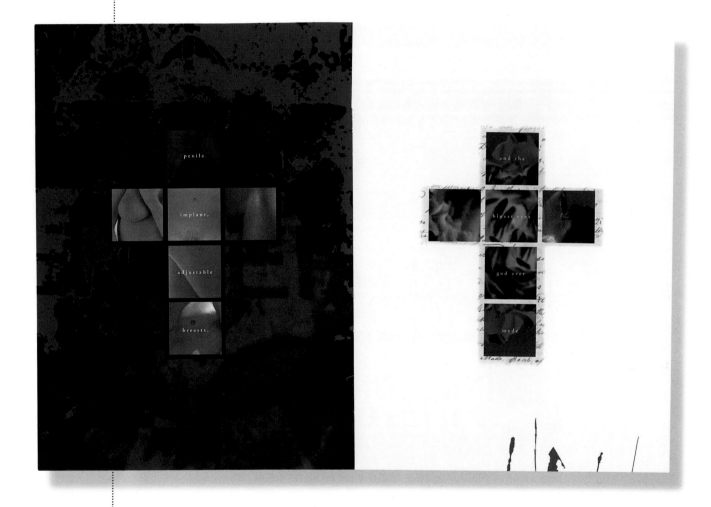

An English professor provided thought-provoking copy for the front pages of an art director's club annual show catalog. "We wanted the introductory section to be a stream-of-consciousness adventure," says designer Kirk Richard Smith. "I like seeing visual metaphors being used as a part of communication." Here, words and images contrast the artificial with the natural. Photos taken from pornographic magazines and ironic copy about "surgeries of convenience" are played against natural and philosophical images that represent "a tip of the hat to the Creator, who managed well with the blue eye contribution."

Studio	CO:LAB
Art Directors	Richard Hollant, Jim Coon
Designer	Richard Hollant
Photographer	Jim Coon Studio
Client	Connecticut Art Directors Club
Software	QuarkXPress, Macromedia FreeHand, Adobe Photoshop
Colors	Four-color process plus three spot match
Special features	Die-cut corners, metallic silver ink, stapled binding

connecticut
art directors club, inc.
p.o. box 639
avon, connecticut 06001

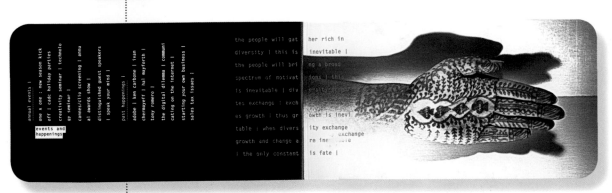

Inspired by the Black Panthers and communists, designer Richard Hollant used this piece to encourage participation, designing the type so that the reader must rotate the piece to read it. "I think it worked pretty well for the group—raffling off a TV might have worked better," he says. "It took-four-color process and three spot colors to do something contemporary that replicates the sensibility of Communist propaganda materials. Boy . . . designers!"

Studio	Matthias-Karim Avice
Art Director	Matthias-Karim Avice
Designer	Matthias-Karim Avice
Photographer	Gilles Barre
Client/Service	TI-RAT/music company
Software	Adobe Photoshop, QuarkXPress
Paper	Couché Moderne Royal Prestige Gloss
Colors	Two, match
Print Run	1,000
Cost Per Unit	250 francs
Type	Harlem-Slang Bold (title), Din (text)

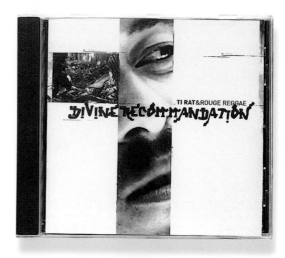

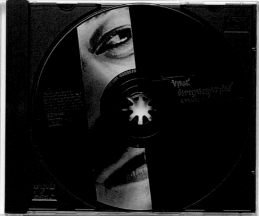

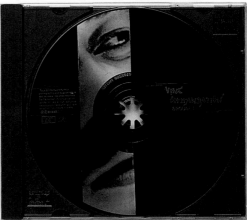

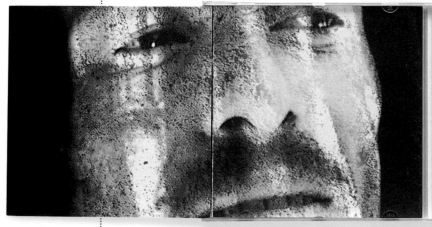

Extensive use of brick red recalls the "rouge reggae" in the band's name. The designer complements small black-and-white pictures of the singer and band with a large texture pattern to produce a pleasing look without a large photography budget.

Studio	[i]e design
Art Director	Marcie Carson
Designers	Marcie Carson, Cya Nelson
Client/Service	MediaPointe/conference room technology
Software	QuarkXPress, Adobe Photoshop, Adobe Illustrator
Paper	Mead Signature (cover), Neenah UV Ultra (text), vellum
Colors	Four-color process plus spot and dull varnish
Print Run	1,000
Special features	Die-cut, fold-in cover
Special production technique	Text and cover were produced by different printers.

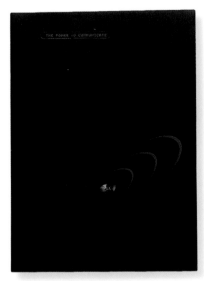

62 | 63

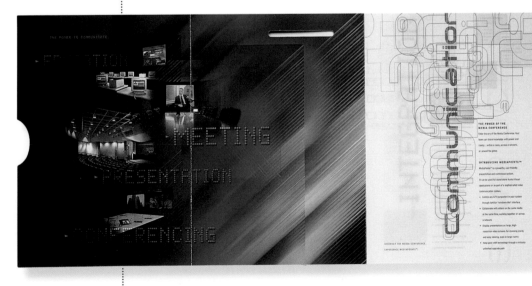

Dull varnish gives the printed black cover of this intriguing brochure an intense, velvety darkness barely broken by the graphic. A die-cut reveals the title, "The Power to Communicate." Inside, the reader finds a dynamic combination of color, graphics and type, all carefully layed out on vellum pages to create layers of messages. Each page reveals the headline of the page that follows, drawing the reader into the text and representing the client's technical and communication strengths.

Studio	Curry Design Associates
Art Director	Steve Curry
Designer	Pyon Mun
Client/Service	Studios USA/syndicated television programming
Software	Adobe Photoshop, Adobe Illustrator
Paper	McCoy Silk
Colors	Eight match plus varnish
Print Run	130,000
Type	Letter Gothic, Frutiger

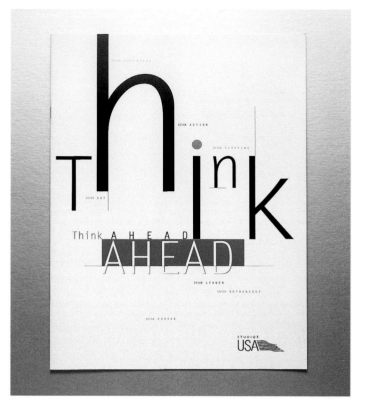

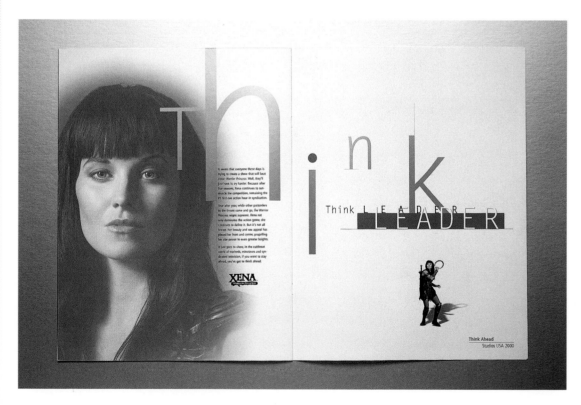

This brochure for syndicated television uses provocative words and images to promise buyers the market appeal of the cult hit Xena, Warrior Princess. Metallic inks are used throughout the slick book, which combines imaginative layout with copy that inspires imaginative thinking. Headers such as "Think Adventure" and "Think Action" reveal each show's main appeal.

Studio	BK Design Group
Art Director	Brenda Kastor
Designer	Brenda Kastor
Client	Self
Software	QuarkXPress, Adobe Photoshop, Adobe Illustrator
Paper	Printer's stock
Colors	Six-over-six; four-color process with spot dull and gloss varnish
Print Run	5,000
Type	Penstyle, Simplix Display, Humanist 521
Special production technique	Off-center fold
Cost-cutting technique	Piggybacked on a client's project

bkdesigngroup

BK Design Group has experienced many exciting changes in the past year, making expansion a necessity. As a result, we are proud to announce the opening of our new offices in Destin, Florida on July 14, 2000.

New offices

New services

More design

....and a real conference room.

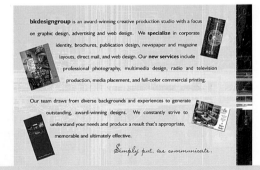

Moving to a new city and a new site, BK Design needed "a distinctive announcement that would draw attention and show off our style and capabilities—but without a lot of cost," says principal Brenda Kastor. By piggybacking on a client's six-color job, BK Design got that piece for only $350. Adding a vellum insert transformed the moving annoucement into an open house invitation.

Studio	Sound Transit In-house Design Studio
Art Director	Anthony Secolo
Designer	Anthony Secolo
Photographers	Peter De Lory, Kenji Tachibana
Copywriter	Bob Wodnik
Client	Central Puget Sound Regional Transit Authority
Software	Macromedia FreeHand, Adobe Photoshop
Paper	Gilbert Clearfold 17# (dust jacket), Utopia 3 Gloss 80# cover (cover), Utopia One Dull 100# text (text), Neenah Classic Crest 100# text (financials)
Colors	Four-color process plus varnish
Print Run	3,500
Type	Akzidenz Grotesk Book Extended, Berthold
Special fold	French-fold dust jacket

To announce the success of its new bus service and the start of construction on four new commuter train stations, Sound Transit needed an annual report that reflected its dynamic growth. In-house designer Anthony Secolo created a bright, modern piece featuring oversize type and bold colors. Beautifully reproduced black-and-white photographs begin in the right gutter of the previous spread, making the piece rush along like a speeding train. A deep blue vellum dust jacket adds depth and mystery to the cover photo—a bus with the words "annual report" on its destination sign.

Studio Mario Aurelio
Colors One, match
Special feature Vellum envelope

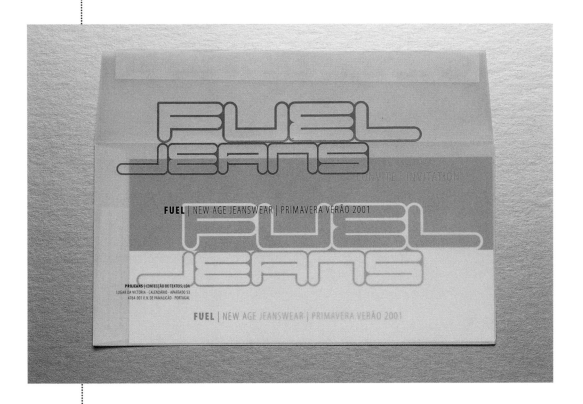

66|67

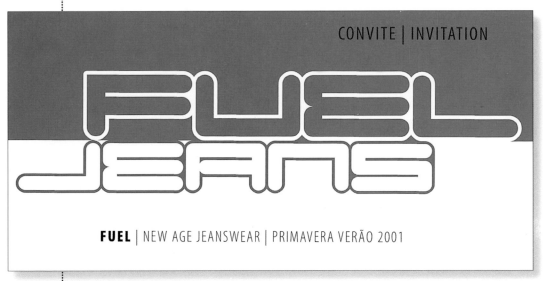

This dynamic invitation grabs attention right through its sheer vellum envelope. The bright orange color and arresting logo can't be ignored.

Studio	D Zone Studio Inc.
Art Director	Joe Yule
Copywriter	Noramae Munster
Photographer	Ray Carofano
Artist	Ron Pippin
Client	Self
Colors	Four, process
Type	Various
Special fold	Stair-stepped accordion fold

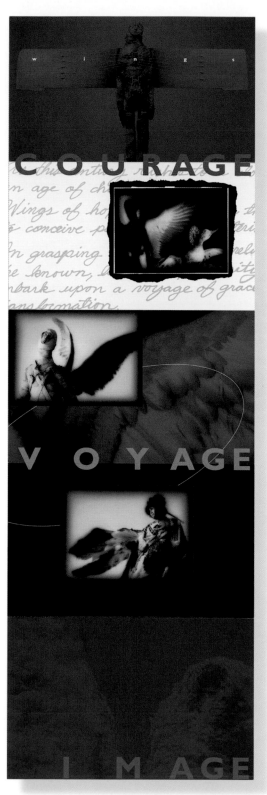

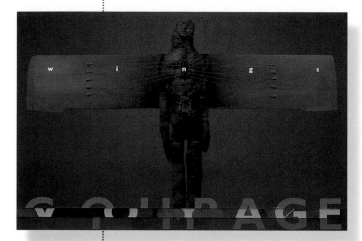

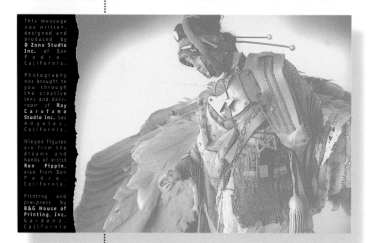

"The way the piece is folded indicates there is a story to be told," copywriter Noramae Munster says of this millennium-themed promo. "The way the type is folded reveals the story in three chapters: courage, voyage and image." Muted colors, reminiscent of sepia tones, give the images an other-worldly look. The type's innovative layout adds emotion. The result is a visual allegory "about a journey we all shared not too long ago."

Studio	Gee + Chung Design
Art Director	Earl Gee
Designers	Earl Gee, Fani Chung, Day Wu
Photographers	Kirk Amyx, stock
Client/Service	Applied Materials/silicon wafer manufacturing
Software	QuarkXPress, Adobe Illustrator, Adobe Photoshop
Paper	Fox River Vicksburg Tiara White 110#
Colors	Four-color process plus two match
Print Run	10,000
Cost Per Unit	$2.75
Type	Trade Gothic, Perpetua, OCRA, Agency Bold, Rockwell Bold Condensed, Futura Bold, Tema Cantante Italic
Special production techniques	Rivet binding, die-cutting
Special type technique	Real SEM (scanning electron microscope) images of silicon chips were cropped to create the letters on the title page

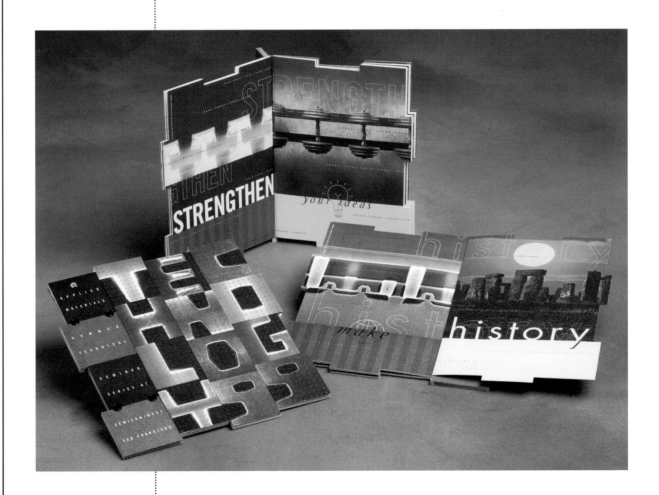

Gee + Chung used the arcane specialty of this brochure's recipients—studying SEM images of silicon chips—to create a dynamic visual. Each spread compares SEM images to photos of everyday life. "We used them to convey conference benefits and themes in a unique, memorable and engaging manner that resonated with the audience," says art director Earl Gee. The riveted binding and unique shape of the piece reflect the manufacturing process of the silicon chip.

Studio	Nielinger & Rohsiepe Kommunikationsdesign
Art Directors	Christian Nielinger and Herbert Rohsiepe
Designer	Herbert Rohsiepe
Photographer	Christian Nielinger
Client	Self
Software	Adobe Photoshop, Macromedia FreeHand
Paper	Arjo Wiggins PopSet 240 g/qm, various colors
Colors	Two, match (HKS system) per month
Type	Clarendon, Trade Gothic
Special features	Wire-O binding, attached cardboard stand
Special cost-cutting technique	Colored paper provides a third color.

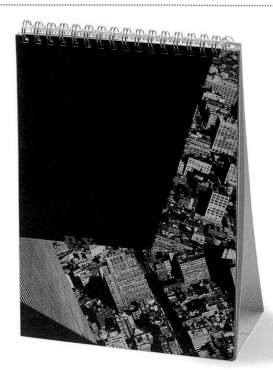

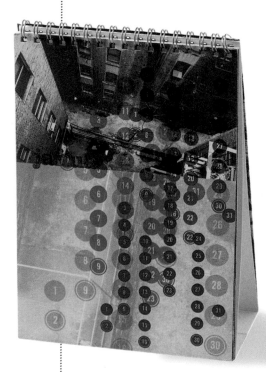

Nielinger & Rohsiepe transforms the utilitarian calendar into a useless but beautiful vehicle for intriguing design in this gift to clients. Black-and-white photographs of New York City become backdrops for an innovative layout of letters and numbers on pages that give the dates—but not days of the week—for months of a year never identified on the piece itself. A fold-out cardboard stand is bound onto the piece for easy display.

Studio : Bernhardt Fudyma Design Group
Art Director : Janice Fudyma
Designer : Angela Valle
Client/Service : The College Board/nonprofit organiza-
tion prepares students for college
Software : Adobe Photoshop, Adobe Illustrator,
QuarkXPress
Colors : Four-color process (cover), two match
(text)

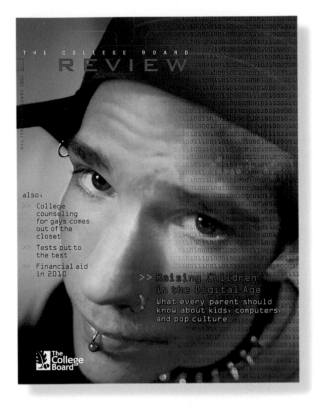

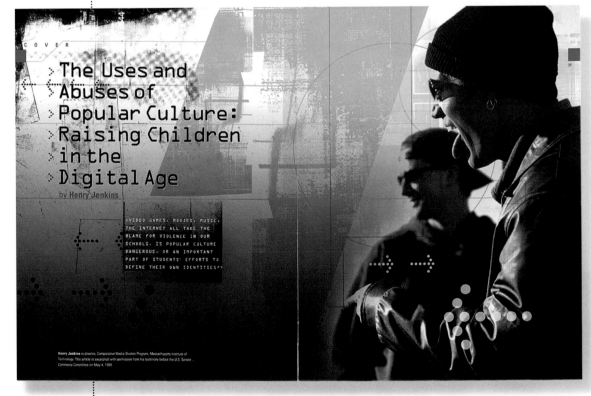

This redesign of a trade magazine for college teachers and administrators gives the publication a bold, friendly look. Innovative type treatments and layouts convey that the magazine tackles tough, contemporary issues. Easy to read and vibrant, the magazine makes clever use of its two colors, with solid blocks of red, black and various combinations, and a mixture of monotone and duotone photographs.

Studio	StudioNorth
Designers	Nicole Bordeau, Laura Budrow, Misty Castaldi, Lynn Gabalec, Lynn Granstrom, Steve Herberger, Erik Peterson, Mark Schneider, Chris Trinco
Copywriters	Dan Gutknecht, LaDonna Willems
Client	Self
Software	Adobe Photoshop, Adobe Illustrator, QuarkXPress
Paper	Potlatch McCoy Silk 100 lb. cover and text
Colors	Four-color process plus two metallics
Print Run	2,000
Cost Per Unit	$8
Type	Various
Special production technique	A special match fluorescent yellow was substituted for process yellow to brighten colors.
Special feature	Four-page center gatefold

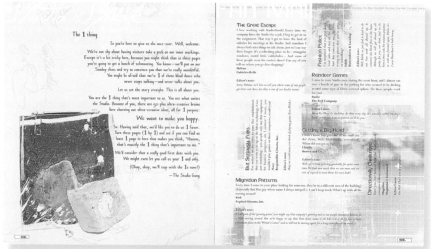

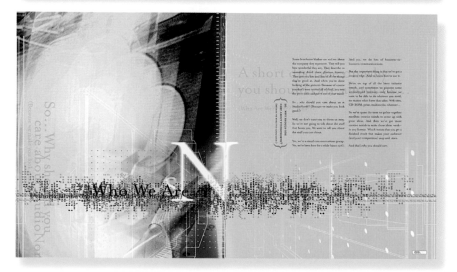

Every designer at StudioNorth created a spread for this promotional magazine, which features even more copy than art. Inventive type treatments give the text-heavy pages their own distinctive voices. "The styles, fonts, techniques and software vary from page to page, which demonstrates our diversity of talent," says Mark Schneider.

Studio	Firehouse 101 Art + Design
Art Director	Kirk Richard Smith
Designers	Kirk Richard Smith, Brad Egnor
Illustrators	Michiko Stehrenberger, Keith Novicki, Marcelle Gilkerson
Copywriter	George Felton
Photographers	Chas Krider, Will Shively, Stephen Webster
Client	Columbus Society of Communicating Arts
Software	Macromedia FreeHand, Adobe Photoshop
Paper	Sterling
Colors	Four-color process plus match silver and dull varnish
Print Run	2,500
Type	Helvetica, Base (by Emigre), Times Roman, Rubber Stamps
Special production techniques	The piece came in a metallic envelope

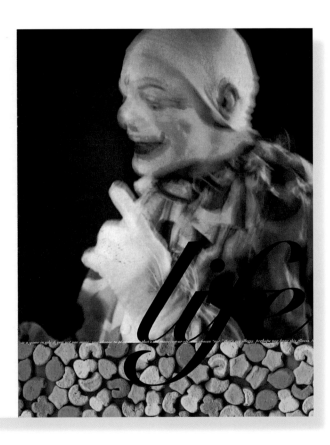

72|73

What is life? This spread from an art director's club annual show catalog answers that question ambiguously—but with a great layout. A blurry photograph of a television clown "seems otherwordly to me," says designer Kirk Richard Smith. "He appears to be lecturing." A border of Lucky Charms cereal fits the theme. On the left, a silhouetted page from a handwritten 19th-century journal contrasts sharply, implying deep and profound thought.

chapter **3 IMAGE**

1 47 76 00 64 104 56 91 8 3435 87 5 768 103 175 8 8335 6 43 1

At our most basic level, we think in symbols, not in words. Words are for reasoning, for explaining, for details. But our deepest thoughts and feelings are in pictures.

Pictures communicate a mood, an idea, an emotion. The symbols may be generally accepted —the hammer and sickle of the former USSR, for instance, reminds most people of Communism—or entirely individual. Both types must be used carefully. The hammer and sickle will have different connotations for Western European than it does for Eastern European audiences. The violent images one individual may find intriguing and modern may seem distasteful and even disgusting to another audience.

These reactions are what make images so powerful. Used well, they communicate straight to the most primitive part of us, evoking a reaction long before we have a chance to analyze their message in words.

Studio	Murphy Design
Art Director	Mark Murphy
Designers	Rafael Lopez, Gary Taxali, Jonathon Rosen, Christian Clayton, Rob Clayton, Jorge Gutierrez, Charles Glaubitz, Joe Sorren
Photographer	Eric Rippert
Client	Self
Software	Macromedia FreeHand, QuarkXPress, Adobe Photoshop
Paper	French standard white, Potlatch 100 lb. McCoy gloss white
Colors	Four, process plus overall gloss
Print Run	5,000
Cost Per Unit	$7.20
Type	Hoefler Text, Champion, Historicals, Leviathon, BeLucian Book, English 157, Zurich, Bodoni, Univers, Clarendon
Special production techniques	"Heavy use of the photocopier, old and battered return-to-sender stamps and a collage of manipulated illustrations."

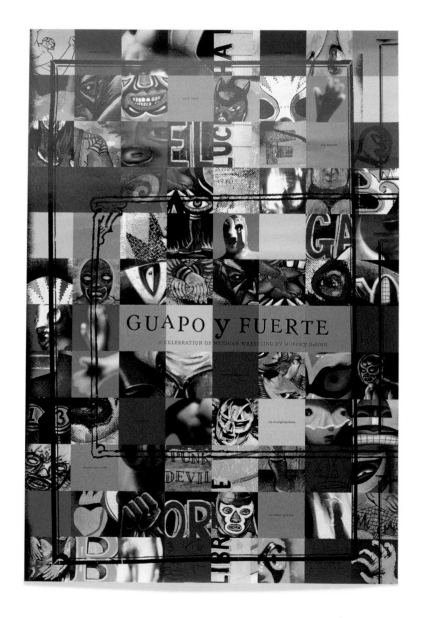

What seems at first to be merely a colorful mosaic becomes, on closer examination, a paen to the lurid glories of Mexican professional wrestling. Bright Mexican colors vie for attention with folk art elements, images of fists and flames and close-up shots of the masks wrestlers wear. It's impossible not to draw closer and experience the mysterious appeal of this wildly popular sport.

Studio	Margo Chase Design Group
Art Director	Margo Chase
Designer	Jonathan Sample
Illustrators	Brian Hunt, Jonathan Sample
Client/Service	Crave Entertainment/CD-ROM game producer
Software	Adobe Photoshop, Adobe Illustrator, QuarkXPress, Cinema 4D
Colors	Four, process
Type	Evolution (Chase Design Group), Info, Bank Gothic
Special features	Gatefold pages, insert
Special type technique	Jade Cocoon logo "created by collaborative sketching followed by vector creation in Illustrator"
Special cost-cutting technique	Digital printing

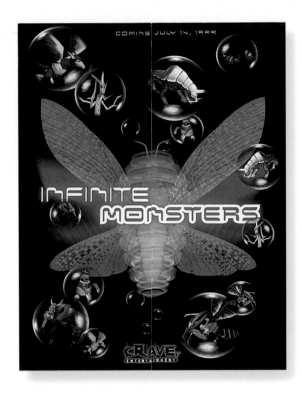

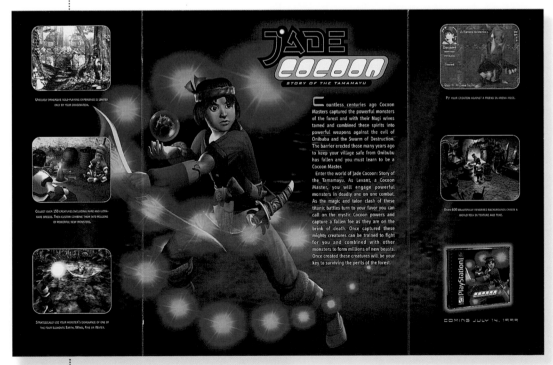

The gatefold cover of this sell sheet for a Sony PlayStation game grabs the buyer's attention by promising "infinite monsters," a special monster-combining feature that lets players create monsters from 160 monster types. Inside, the player is introduced to the game and its main character in the central panel. Like a medieval triptych, the two foldout sections show exciting scenes from the story.

Studio	slow HEARTH studio
Art Directors	Sean and Katie Mosher-Smith
Designers	Sean and Katie Mosher-Smith
Photographers	Sean and Katie Mosher-Smith
Client	Self
Software	Adobe Photoshop, QuarkXPress
Colors	Four, process
Type	Impact, Gill Sans, Univers Condensed

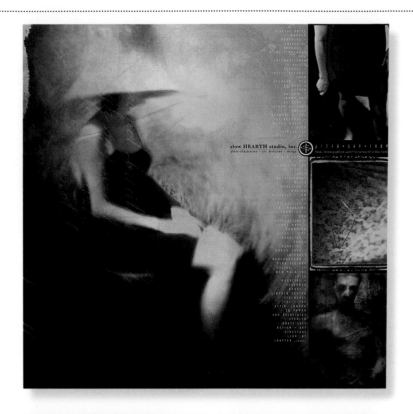

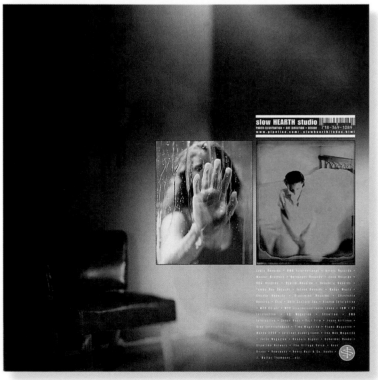

Both pieces were designed for a sourcebook that overprinted its run and sold the extra pieces to clients as mailers. The studio, which specializes in photography and design for the music industry, used the pages to showcase its unique style. "We are usually asked to create ethereal and dark images that have a slightly disturbing quality," says co-art director Sean Mosher-Smith. "We do manage to add some humor, like the lampshade on the model's head. We just saw this wonderful shape and decided it should be in the piece somehow. It fit perfectly on her head!"

Studio	Chronicle Books
Art Director	Sara Schneider
Designer	Sara Schneider
Photographer	Deborah Jones
Client	Self
Software	QuarkXPress, Adobe Photoshop, Adobe Illustrator
Paper	157 gsm matte art
Colors	Four, process plus one match
Print Run	15,000
Cost Per Unit	$1.55
Type	Emigre Vendetta, Franklin Gothic
Special production technique	Custom match color

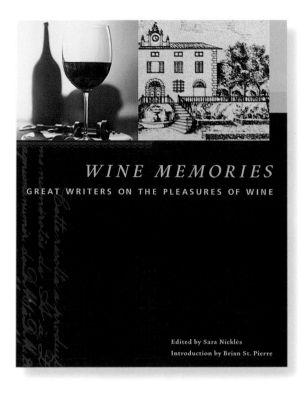

WINE MEMORIES

GREAT WRITERS ON THE PLEASURES OF WINE

Edited by Sara Nicklès
Introduction by Brian St. Pierre

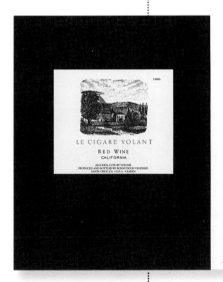

Neither Pantone nor Toyo offered an ink formula that reproduced the burgundy color art director Sara Schneider wanted to feature in this book of literary excerpts. So the printer created a custom brownish-red for the cover and throughout the book. Inside, reproductions of labels from "celebrated vintages and vineyards" separate the texts, which consist of musings on fine wine by a wide-ranging selection of authors.

Studio	Flaunt Magazine/Eric Roinestad Design
Art Directors	Eric Roinestad (cover), Eric Roinestad and Jim Turner (spreads)
Designer	Eric Roinestad
Photographers	Warwick Saint (cover and cover feature), Mikako Koyama (cutlery spreads)
Client	Flaunt Magazine
Software	QuarkXPress, Adobe Photoshop
Colors	Four, process
Print Run	90,000
Type	Hand-lettered logo, Din Bold, Light and Medium (by Albert-Jan Pool), Meta Normal and Black (by Erik Spiekermann)
Special production techniques	Die-cut and embossed cover, die-cut holes in Julianne Moore story

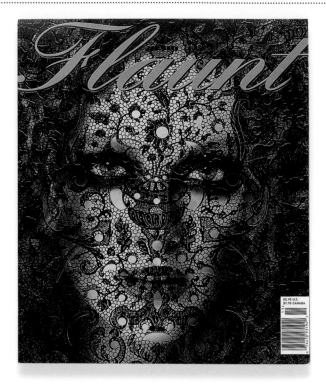

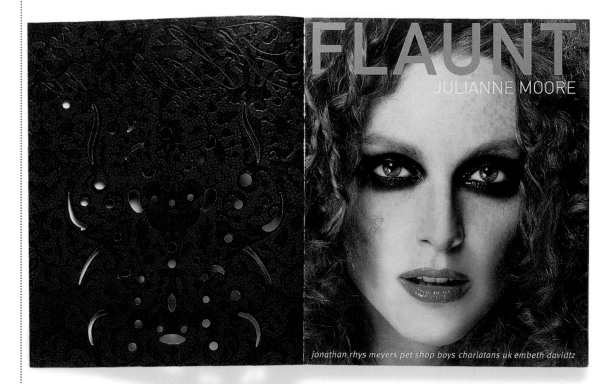

With a name like Flaunt, you're already revealing a lot—even with a die-cut and embossed cover that hides actress Julianna Moore's face behind sheer black lace. Die-cut holes also introduce the cover feature, which includes more photos of the subject looking like a character from The Rocky Horror Picture Show. *Elsewhere, in one of the magazine's signature bizarre fashion and houseware shoots, fine flatware is shown piercing dead animals.*

NOTHANKSGIVEN

photographed by Mihoko Koyama

Classic designs in cutlery point to the question:
Are you what you eat, or what you eat *with*?
Just some food for thought.

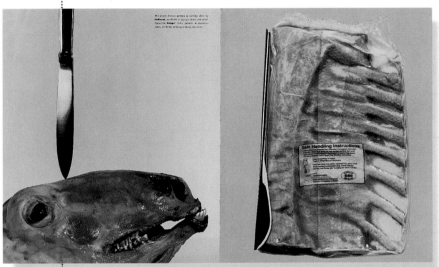

MOORE THAN A WOMAN

written by Dale Brasel photographed by Warwick Saint

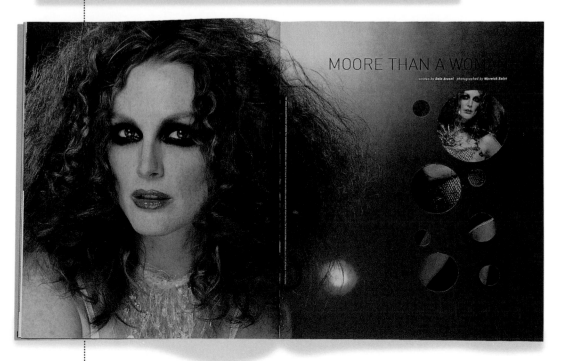

Studio	Wayne Ford
Art Director	Wayne Ford
Designer	Wayne Ford
Illustrator	Dolphin ("Box of Tricks")
Photographer	Raymond Meier ("Digital Couture")
Editor	Susan Weekes
Client	Haymarket Trade & Leisure Publications Ltd.
Software	QuarkXPress, Adobe Photoshop
Paper	Metsa Serla
Colors	Four, process
Print Run	12,000
Type	Arbitrary Sans Regular (by Barry Deck), SG Futura Extra Bold Headline (by Edwin W. Shaar), SG Futura Bold (by Paul Renner)

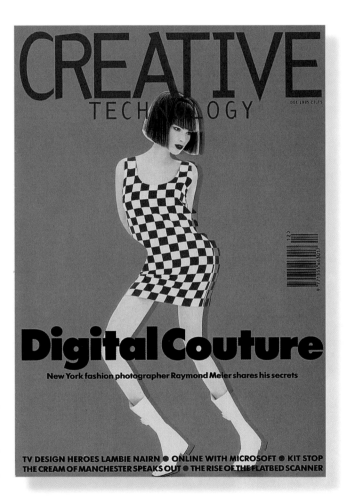

Provocative images are of paramount importance to Creative Technology. *Defying the conventional publishing wisdom of making tag lines big, the magazine relegates them to two lines at the top or bottom of the cover. Even the bold masthead plays second fiddle to the cover shot.*

Studio	West & Vaughan
Creative Director	Robert Shaw West
Art Director	Robert Shaw West
Designer	Robert Shaw West
Illustrator	Stephen Foster
Client/Service	Orange County Speedway/stock car track
Software	QuarkXPress, Adobe Illustrator, Adobe Photoshop
Paper	Various
Colors	Four, process plus one match
Print Run	10,000
Type	Bell Gothic

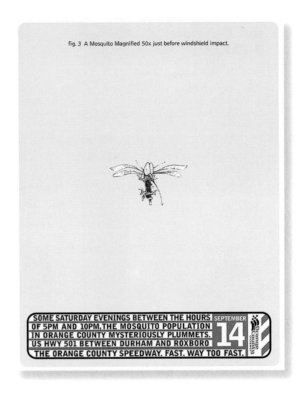

fig. 3 A Mosquito Magnified 50x just before windshield impact.

SOME SATURDAY EVENINGS BETWEEN THE HOURS OF 5PM AND 10PM, THE MOSQUITO POPULATION IN ORANGE COUNTY MYSTERIOUSLY PLUMMETS. US HWY 501 BETWEEN DURHAM AND ROXBORO THE ORANGE COUNTY SPEEDWAY. FAST. WAY TOO FAST. SEPTEMBER 14

82|83

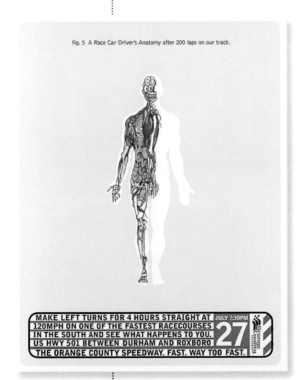

fig. 5 A Race Car Driver's Anatomy after 200 laps on our track.

MAKE LEFT TURNS FOR 4 HOURS STRAIGHT AT 120MPH ON ONE OF THE FASTEST RACECOURSES IN THE SOUTH AND SEE WHAT HAPPENS TO YOU. US HWY 501 BETWEEN DURHAM AND ROXBORO THE ORANGE COUNTY SPEEDWAY. FAST. WAY TOO FAST. JULY 7:30PM 27

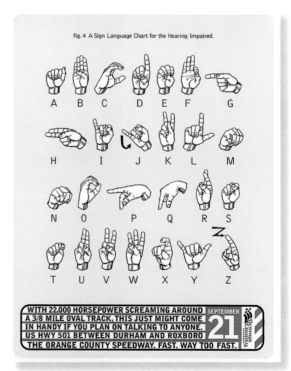

fig. 4 A Sign Language Chart for the Hearing Impaired.

A B C D E F G
H I J K L M
N O P Q R S
T U V W X Y Z

WITH 22,000 HORSEPOWER SCREAMING AROUND A 3/8 MILE OVAL TRACK, THIS JUST MIGHT COME IN HANDY IF YOU PLAN ON TALKING TO ANYONE. US HWY 501 BETWEEN DURHAM AND ROXBORO THE ORANGE COUNTY SPEEDWAY. FAST. WAY TOO FAST. SEPTEMBER 21

Designed as magazine ads, newspaper ads and posters, these pieces for a stock car track use illustrations to convey just what happens when cars go 120 mph—"without getting real gross," says creative director Robert Shaw West. "What's not to like at a speedway? Good, clean, gut-turning, earsplitting fun for a bunch of drunken rednecks." Four, process was the best choice for the pieces, says West, because it encouraged the college student target audience to hang the posters up in their rooms.

Studio	Cartoon Network Trade Creative Service
Creative Director	Gary Albright
Art Director	Cathe Jacobi
Designers	Joe Williams and Annie Liebert, Imagico Studio
Illustrators	Gary Hartle, John Horn, Phillip Horn
Client	Self
Software	QuarkXPress, Adobe Illustrator
Colors	Four, process
Type	Fink Sans, ITC Highlander
Special features	Hardcover containing CD holder, spiral binding, die-cut divider pages

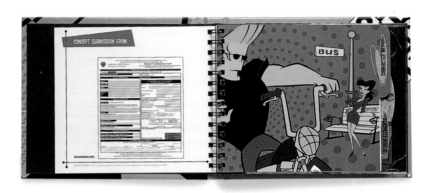

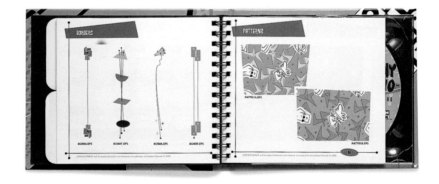

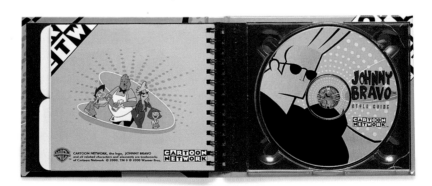

A guide for designers creating branded merchandise, the jewel-box-size Johnny Bravo Style Guide contains anything and everything necessary to capture the distinctive retro style of the television cartoon. PMS charts, characters in various poses, backgrounds, borders and other elements are shown in the four-color pages and supplied on the CD included in the back cover. The book itself demonstrates how attention to period detail makes the cartoon's tongue-in-cheek design work.

Studio	La Boite á Lettres
Art Director	Matthais-Karim Avice
Designer	Matthais-Karim Avice
Client/Service	CTV International/film maker
Software	Adobe Photoshop, Adobe Illustrator, QuarkXPress
Paper	Job Parilux Brilliant
Colors	Four, process
Print Run	4,000
Cost Per Unit	350 francs
Type	FunHouse (title), MetaPlus (text)
Special features	UV coating ("Pellicualge R° V° Brillant")

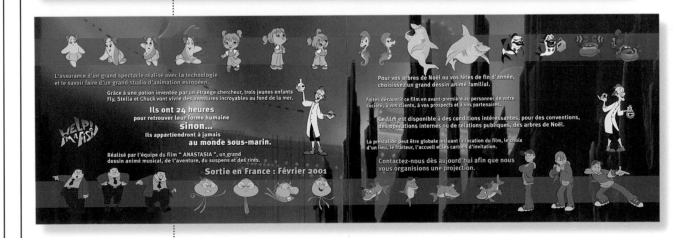

84|85

Extensive use of animation stills and backgrounds introduce a European children's film. On the cover, the three characters (as children, in the red band, and transformed into fish, in the blue band) balance graphically with the film title and advertising copy. Inside, brief text explains opportunities for advanced screenings. But the animation stills running along ribbons of bright blue remain the stars.

Studio	Hesse Designstudios GmbH
Art Director	Klaus Hesse
Designer	Carolin Niemann
Illustrator	Verena Landgraf
Photographers	Christian von Alvensleben, Andreas Koerner (accessories)
Client	Schemmrich KG
Software	QuarkXPress
Paper	Gardapat 13, 115g/qm
Colors	Four, process
Print Run	7,000
Cost Per Unit	2.50 Euro
Type	FF-Din
Special features	Spiral binding, bound-in and die-cut looseleaf binder attachment

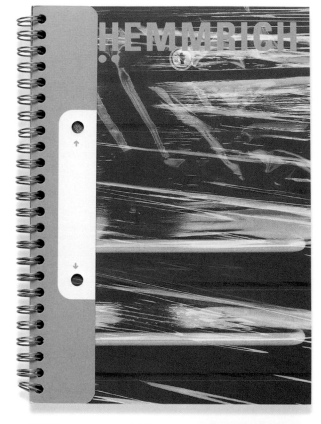

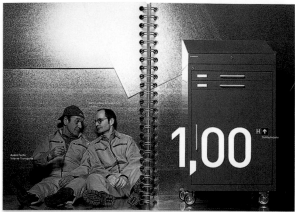

Icons, bars and arrows give this catalog for industrial shelving and workbenches the look of a Web page. But what makes it unique is what's between the product pages: a running conversation between inventor Karl-Ludwig Schemmerich and factory workers—who become the rugged worksuit-clad models in beautiful product photographs. The combination of words and faces connects the precision-manufactured product with its human manufacturers and, by extension, its customers.

Studio : West & Vaughan
Creative Director : Robert Shaw West
Art Director : Scott Pridgen
Designer : Scott Pridgen
Photographer : Alex Bee
Client/Service : SoftPro/software developer
Software : QuarkXPress, Adobe Illustrator, Adobe Photoshop
Colors : Four, process
Type : Futura

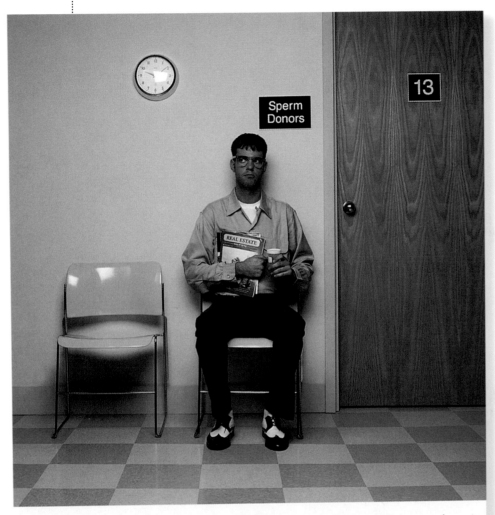

Closings. Maybe we like them a little too much.

Real Estate
Closing
Software

86|87

How much does this client enjoy real estate closings? One picture tells it all in this software ad.
"The interesting part about this product is the notion that it automates the terrible process of doing
a closing, the job all attorneys hate," says creative director Robert Shaw West. "The people of SoftPro
really love doing this crap—it was so weird for someone to love their job sooo much."

Studio	Dwell magazine
Art Director	Jeanette Hodge Abbink
Designers	Shawn Hazen, Jeanette Hodge Abbink (premiere cover), Joseph Stitzlein (logo)
Illustrator	Atlas Industries (table of contents)
Photographers	Doeg Hoeschler (October cover), Robert Cardin (vacuum spread), Rick Olivier (December cover), Ben Fink and Bob Ocken (Arkansas spread), Ben Fink, Rick Olivier, Miranda Lichtenstein, Brad A. Smith/Photosmith, Dwight Eschliman, Wade Spees, Patrick Bingham Hall (table of contents)
Client	Self
Software	QuarkXPress, Adobe Illustrator, Adobe Photoshop
Paper	130# Sterling Matte (cover), 60# Somerset Matte (text)
Colors	Four, process plus one match
Print Run	103,000–145,000
Type	Trade Gothic family (by Jackson Burke)

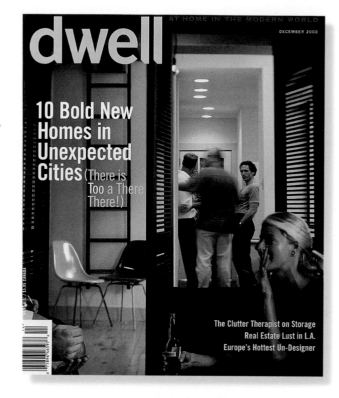

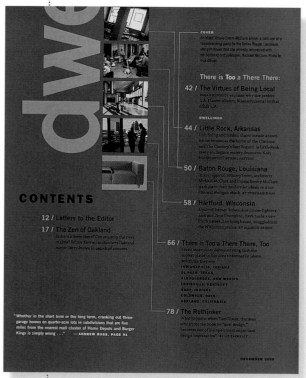

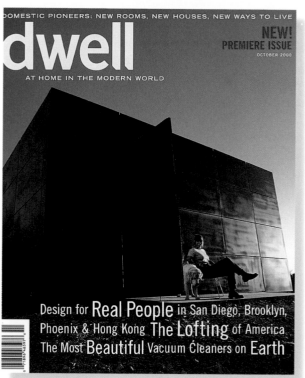

Dwell reveals its refreshing focus on how people really live in modern buildings by setting its contents in a fresh, modern design. Joseph Stitzlein created the bold masthead by modifying Trade Gothic. An intriguing modular layout makes even the table of contents interesting, while spreads balance photos and text in pleasing, easy-to-read harmony. Designer Shawn Hazen coaxes PR and product artwork into novel looks through innovative layout, such as silhouettes, cut-outs and close-up details.

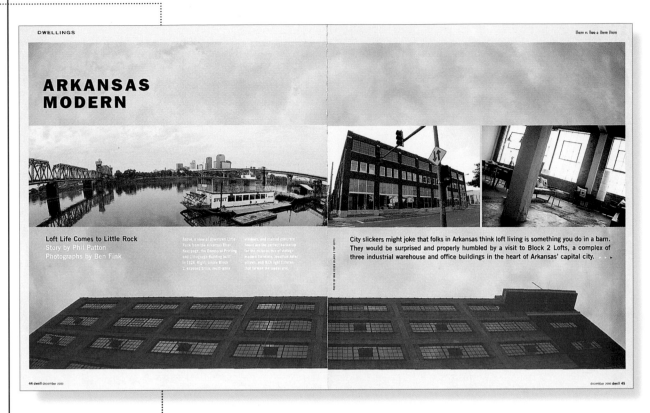

ARKANSAS MODERN

Loft Life Comes to Little Rock
Story by Phil Patton
Photographs by Ben Fink

Above, a view of downtown Little Rock from the Arkansas River. Next page, the Democrat Printing and Lithograph Building built in 1924. Right, inside Block 2, exposed brick, multi-pane windows, and stained concrete floors are the perfect backdrop for the eclectic mix of vintage modern furniture, Jonathan Adler pillows, and IKEA light fixtures that furnish the model unit.

City slickers might joke that folks in Arkansas think loft living is something you do in a barn. They would be surprised and properly humbled by a visit to Block 2 Lofts, a complex of three industrial warehouse and office buildings in the heart of Arkansas' capital city.

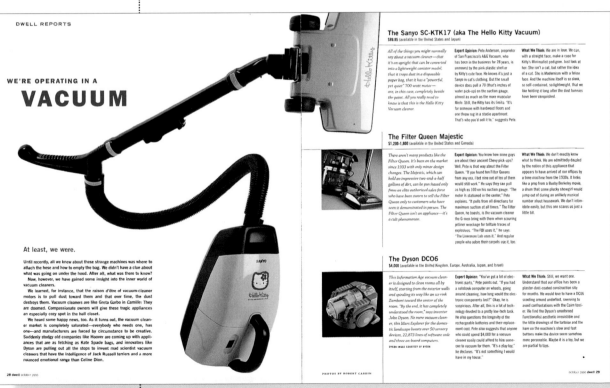

WE'RE OPERATING IN A VACUUM

At least, we were.

Until recently, all we knew about these strange machines was where to attach the hose and how to empty the bag. We didn't have a clue about what was going on under the hood. After all, what was there to know?

Now, however, we have gained some insight into the inner world of vacuum cleaners.

We learned, for instance, that the raison d'être of vacuum-cleaner motors is to pull dust toward them and that over time, the dust destroys them. Vacuum cleaners are like Greta Garbo in *Camille*: They are doomed. Compassionate owners will give these tragic appliances an especially cozy spot in the hall closet.

We heard some happy news, too. As it turns out, the vacuum cleaner market is completely saturated—everybody who needs one, has one—and manufacturers are forced by circumstance to be creative. Suddenly stodgy old companies like Hoover are coming up with appliances that are as fetching as Kate Spade bags, and innovators like Dyson are pulling out all the stops to invent mad scientist vacuum cleaners that have the intelligence of Jack Russell terriers and a more nuanced emotional range than Celine Dion.

The Sanyo SC-KTK17 (aka The Hello Kitty Vacuum)
$89.95 (available in the United States and Japan)

All of the things you might normally say about a vacuum cleaner—that it's an upright that can be converted into a lightweight canister model, that it traps dust in a disposable paper bag, that it has a "powerful, yet quiet" 700-watt motor—are, in this case, completely beside the point. All you really need to know is that this is the Hello Kitty Vacuum cleaner.

Expert Opinion: Pete Anderson, proprietor of San Francisco's A&G Vacuum, who has been in the business for 28 years, is unmoved by the pink plastic shell or by Kitty's cute face. He knows it's just a Sanyo in cat's clothing. But the small device does pull a 70 (that's inches of water pick-up) on the suction gauge, almost as much as the more muscular Miele. Still, the Kitty has its limits: "It's for someone with hardwood floors and one throw rug in a studio apartment. That's who you'd sell it to," suggests Pete.

What We Think: We are in love. We can, with a straight face, make a case for Kitty's Minimalist pedigree. Just look at her. She isn't a cat, but rather the idea of a cat. She is Modernism with a feline face. And the machine itself is so sleek, so self-contained, so lightweight, that we like holding it long after the dust bunnies have been vanquished.

The Filter Queen Majestic
$1,200–1,800 (available in the United States and Canada)

There aren't many products like the Filter Queen. It's been on the market since 1933 with only minor design changes. The Majestic, which can hold an impressive two-and-a-half gallons of dirt, can be purchased only from an elite authorized sales force who have been sworn to sell the Filter Queen only to customers who have seen it demonstrated in person. The Filter Queen isn't an appliance—it's a cult phenomenon.

Expert Opinion: You know how some guys are about their ancient Chevy pick-ups? Well, Pete is that way about the Filter Queen. "If you found ten Filter Queens from any era, I bet nine out of ten of them would still work." He says they can pull as high as 100 on his suction gauge. "The motor is stationed in the center," Pete explains. "It pulls from all directions for maximum suction at all times." The Filter Queen, he boasts, is the vacuum cleaner the G-men bring with them when scouring jetliner wreckage for telltale traces of explosives. "The FBI uses it," he says. "The Livermore Lab uses it." And regular people who adore their carpets use it, too.

What We Think: We don't exactly know what to think. We are admittedly dazzled by the notion of this appliance that appears to have arrived at our offices by a time machine from the 1930s. It looks like a prop from a Busby Berkeley movie, a drum that some plucky showgirl would jump out of during an unlikely musical number about housework. We don't intimidate easily, but this one scares us just a little bit.

The Dyson DC06
$4,000 (available in the United Kingdom, Europe, Australia, Japan, and Israel)

This Information Age vacuum cleaner is designed to clean rooms all by itself, starting from the exterior walls and spiraling its way like an ice rink Zamboni toward the center of the room. "By the end, it has completely understood the room," says inventor John Dyson. No mere vacuum cleaner, this Mars Explorer for the domestic landscape boasts over 50 sensory devices, 22,873 lines of software code, and three on-board computers.

Expert Opinion: "You've got a lot of electronic parts," Pete points out. "If you had a notebook computer on wheels, going around cleaning, how long would the electronic components last?" Okay, he is suspicious. After all, this is a lot of technology devoted to a pretty low-tech task. He also questions the longevity of the rechargeable batteries and their replacement cost. Pete also suggests that anyone who could spend $4,000 for a vacuum cleaner easily could afford to hire someone to vacuum for them. "It's a play toy," he declares. "It's not something I would have in my house."

What We Think: Still, we want one. Understand that our office has been a plaster-dust-coated construction site for months. We would love to have a DC06 scooting around underfoot, swerving to avoid confrontations with the Cairn terrier. We find the Dyson's unadorned Functionalist aesthetic irresistible and the little drawings of the tortoise and the hare on the machine's slow and fast buttons make the device seem somehow more personable. Maybe it is a toy, but we are partial to toys.

PHOTOS BY ROBERT CARDIN
DYSON IMAGE COURTESY OF DYSON

Studio	Dwell Magazine
Art Director	Jeanette Hodge Abbink
Designers	Jeanette Hodge Abbink (cover), Shawn Hazen (spread)
Photographers	Todd Hido (cover), Richard Ross, courtesy J. Paul Getty Museum (spread)
Client	Self
Software	QuarkXpress, Adobe Illustrator, Adobe Photoshop
Paper	130# Sterling Matte (cover), 60# Sunset Matte (text)
Colors	Four, process plus one match
Print Run	165,000
Type	Trade Gothic family (by Jackson Burke)

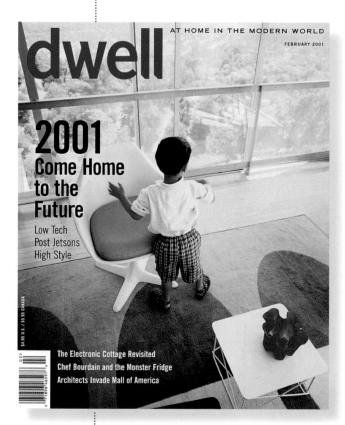

People are often featured in Dwell's photographs, a foreign concept to most architectural photographers. But there's room for plain interior shots too, such as this moody opener for a piece on lighting. "I made the headline a deep tint that I matched to a color proof from our pre-press house so that the type would be gloomy," says designer Shawn Hazen. "I wanted to enhance the effect of the poorly lit room."

Studio	Y Design
Art Director	Martin Ogoltier
Designer	Martin Ogoltier
Photographer	Roderick Angle
Client/Service	The Apartment/retail
Software	Adobe Illustrator
Colors	Four, process
Print Run	2,000
Type	News Gothic, Courier

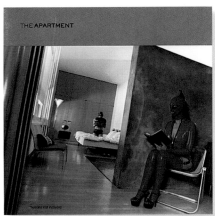

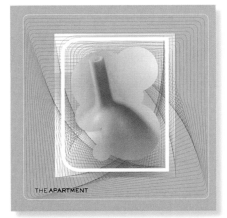
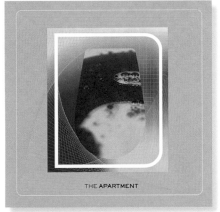
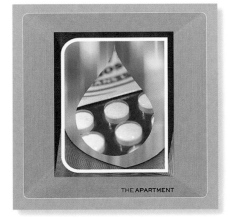
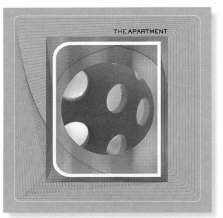

90|91

This press kit approaches a home furnishing shop's novel concept—creating a model apartment each month and letting customers order the contents—in an equally novel way. A square greeting card-style folder holds five square cards, each with an ambiguous but intriguing close-up image on one side and a pithy comment surrounded by white space on the other. "The idea was not to just show the products that will be sold," says art director Martin Ogoltier, "but to suggest a vibe with individual cards, abstract yet personal."

Studio Mãrio Aurélio & Associados
Client/Service Onara Industria e Comercio de
Textéis, Ida/Clothing

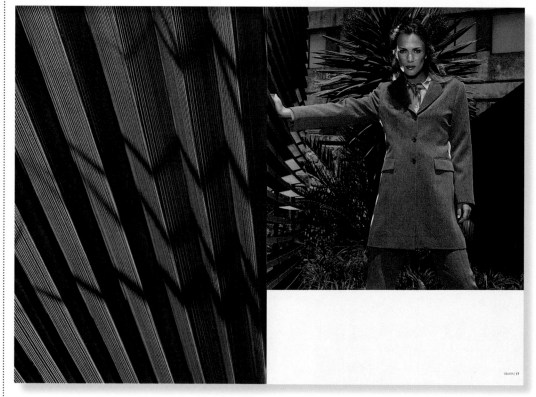

A close-up textile photo becomes an evocative and mysterious cover for this brochure that introduces
an international clothing and retail business based in Portugal. One page of text shown in a simple,
contemporary block layout tells the story, leaving the rest of the book to fashion shots and nature
photos. Bands of white space break up the four-color pages. This full-page image of palm leaves gives
the model photo context and recalls the mood of the cover shot.

Studio	Murphy Design
Designer	Mark Murphy
Illustrator	Mark Murphy
Client	AIGA Colorado
Software	Macromedia FreeHand
Paper	French Frostone white 80 lb.
Colors	four, match
Print Run	2,500
Cost Per Unit	$0.70
Type	Dogma, hand drawn
Special type technique	Custom letters were created by hand, scanned and redrawn in FreeHand

Bold swaths of four match colors give this poster for an exhibit sponsored by AIGA Colorado the look of a screenprinted piece. The devilish icon, thoroughly modern in design, presides triumphantly over ghosted graphics that symbolize things gone wrong: illustrations of wrenches, "return to sender" stamps and bodies marked with pressure points.

Studio	Life: The Observer Magazine
Art Director	Wayne Ford
Designer	Wayne Ford
Photographers	Patrice de Villiers ("The Fish Issue"), Francesca Woodman, The Estate of Francesca Woodman ("The Lady Vanishes")
Picture Editor	Jennie Ricketts
Client	Self
Software	QuarkXPress, Adobe Photoshop
Colors	Four, process
Print Run	500,000
Type	Berthold Evo Medium and Bold (by Marco Ganz), heads; FF Scala (by Martin Majoor), text

Provocative photography and bold layout give The Observer Magazine an outstanding look among weekly magazines in British newspapers. For "The Lady Vanishes," a spread about mysterious photographer Francesca Woodman, art director Wayne Ford gives the intriguing headline and compelling photos equal weight. On the cover of "The Fish Issue," Ford uses a highly textured close-up shot to whet the reader's appetite.

Left: 'House #3',
Providence, Rhode
Island, 1975-1976

Right: Untitled,
Providence,
Rhode Island, 1976

Words **Gaby Wood**

The lady vanishes

The artist Francesca Woodman died in 1981, after jumping from
the window of her New York apartment. She left behind a body
of work that is all about identity, disappearance and impermanence.
It's as if she obliterated herself from her photographs long before
she decided to vanish from life itself

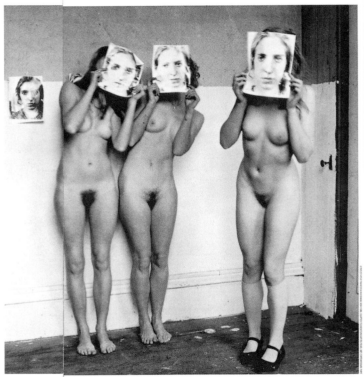

Studio	George Tscherny, Inc.
Creative Director	Silas H. Rhodes
Designer	George Tscherny
Illustrator	George Tscherny
Photographer	George Tscherny
Client	School of Visual Arts
Software	Adobe Photoshop, QuarkXPress
Paper	Neena Classic Crest
Colors	Four, process
Print Run	2,500
Type	Berthold Antiqua Bodoni, hand-brush lettering

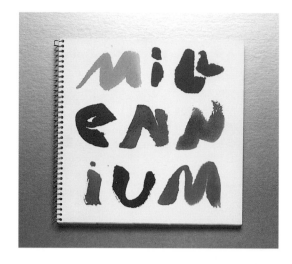

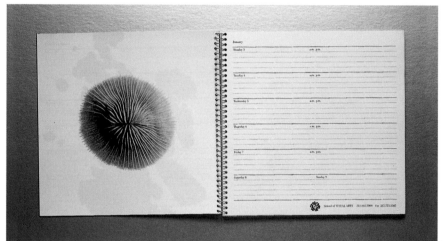

A selection of bright watercolors and textured black-and-white photographs pose wordless questions. "The tension between chance and control," says artist George Tscherny, "is the unifying theme. Both are likely to be present in any kind of artistic expression. I have tried to function in either mode. Accepting chance requires mental looseness, while creating it demands manual dexterity."

Studio	Firehouse 101 Art + Design
Art Director	Kirk Richard Smith
Designers	Kirk Richard Smith, Brad Egnor
Illustrators	Michiko Stehrenberger, Keith Novicki, Marcelle Gilkerson
Photographers	Chas Krider, Will Shively, Stephen Webster
Copywriter	George Felton
Client	Columbus Society of Communicating Arts
Software	Macromedia FreeHand, Adobe Photoshop
Paper	Sterling
Colors	Four, process plus match silver and dull varnish
Print Run	2,500
Type	Helvetica, Base (by Emigre), Times Roman, Rubber Stamps

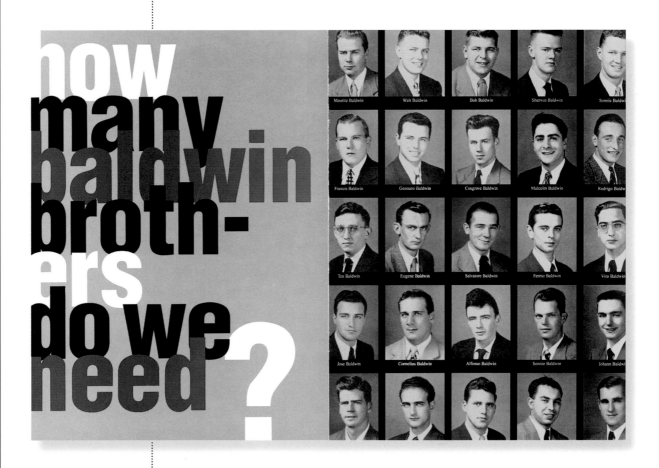

96|97

Type and photography play equal parts in this spread from an art director's club annual show catalog. Large overlapping letters in bold colors ask a simple question. A mosaic of supposed Baldwin brothers ("Alfonso Baldwin, Cosgrove Baldwin, Johann Baldwin") suggests an arch answer. Designer Kirk Richard Smith took the page from a 1957 high school yearbook. "All of these young men looked like they were already in their forties," he says. "I thought they would be good candidates for the Baldwin family."

Studio	Murphy Design Inc.
Designer	Mark Murphy
Illustrators	Gary Taxali, Amy Guipp, Joel Nakamura, Rafael Lopez, Cathie Bleck, Charles Glaubitz, Joe Sorren, Christian Northeast, Vivienn Flesher
Photographer	Eric Rippert
Client	Sante Fe Illustrators Conference
Software	Macromedia FreeHand, QuarkXPress
Paper	Georgia Pacific
Colors	Four, process
Print Run	5,000
Type	Clarendon, Univers Black, Univers Condensed, Hoefler Text, Champion

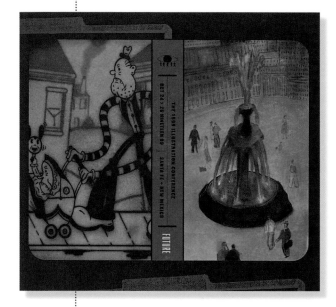

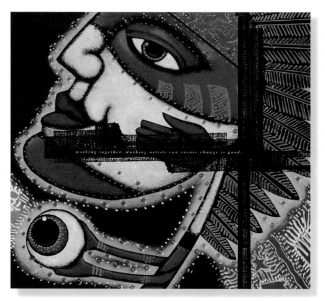

Tea-stained colors poke fun at this economical mailer/poster for an illustrator's conference by giving it an aged look that helps disguise its lack of slick paper and expensive printing techniques. Unfolding the piece gradually reveals its message and displays the different work of several illustrators.

Studio	Wayne Ford
Art Director	Wayne Ford
Designer	Wayne Ford
Editor	Anna Bailey
Photographers	Jens Lucking, David Denny, Elisa Krey, Matthew Burlem, Lenha Reyn H. , David Balhuizen, Carolyn Barber, Martin Bennett, Jo Broughton, Dan Brownsword, James Deavin, Russell Duncan, Gary Edwards, Jim Fenwick, Ben Fisher, Matthew Georgeson, Stefanie Hafner, Nicholla Longley, David Lidbetter, Alex MacDonald, James Marsden, Richard Maxted, Paul Moffat, Charlotte Murphy, Sue Parkhill, Véronique Rolland, Ben Stockley, Mark Westerby, Jasper White
Client	Association of Photographers Assistants
Software	QuarkXPress
Colors	Four, process
Print Run	1,500
Type	Griffith Golthic Light and Ultra (Tobias Frere-Jones)
Special feature	Flexibound cover

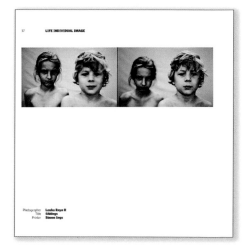

A simple grid showcases the winners of an annual photography contest. Generous margins of glossy white paper separate the disparate photos, making each distinct and whole even when paired with another on a spread. Minimal type presents the winner's name and the photo title without taking away from each photo's impact.

Studio	Designaholix
Art Director	John Jenson
Designers	David and John Jenson
Illustrators	David and John Jenson
Photographers	David and John Jenson
Client	Self
Software	QuarkXPress, Adobe Photoshop, Adobe Illustrator
Colors	Four, process
Type	Neo (John Jenson)
Special type technique	Jenson drew the letters with a technical ink pen, then manipulated them in Adobe Photoshop.
Special cost-cutting techniques	Digital photography and scanning

A black-and-white image of a skull combines with frenetic, colored line illustrations and custom type in this editorial illustration. "The combination of traditional photography and illustration techniques with digital multimedia is very useful and saves us time," says art director John Jenson.

Studio Prototype 21
Art Director Prototype 21
Designer Paul Nicholson
Illustrator Paul Nicholson
Client Self
Software Corel Draw
Colors Four, process
Print Run 2,000
Type OCR-B, Prototype 21 Stencil (mailer), Machine,
 Compacta (poster)

100 | 101

Prototype 21 prints branded clothes, including its own T-shirt line. The poster—a T-shirt design reused as a pin-up—features Japanese anime art and a subject guaranteed to please a stereotypical macho construction worker (or, more likely, a young computer nerd). The mailer shows a serigraph-style illustration of a garment printer on one side, and examples of what that machine can do on the other.

Studio	Iconologic
Creative Director	Brad Copeland
Designer	Rebecca D'Attilio
Illustrator	Various
Photographer	Various
Copywriter	Rodney Rogers
Client/Service	Georgia-Pacific Corp./paper manufacturing
Software	QuarkXPress
Paper	Georgia-Pacific Nekoosa Solutions, Nekoosa Linen, Nekoosa Feltwaeve, Proterra
Colors	Four, process plus various match colors
Print Run	10,000
Cost Per Unit	$16
Type	Gill Sans Techno, Trade Gothic, Mrs. Eaves, News Gothic, Trajan, Clarendon
Special production techniques	Embossing, debossing, foil stamping, sculpted embossing, touch plates, thermography, die-cut rounded corners, Wire-O binding, tinted varnish
Special folds	French fold covers and embossed pages

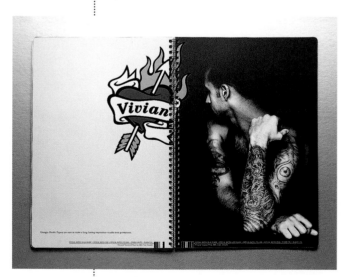

Creative director Brad Copeland pulled out all the stops for this paper promotion, showing how the featured papers perform under a gamut of special printing techniques. "Skin" provided a unifying theme for imaginative images and metaphors. Sculpted embossing on heavy paper, French-folded to provide a smooth back surface, creates texture. Tinted varnishes, intriguingly insubstantial, add an equally striking touch.

Studio	CO:LAB
Art Director	Richard Hollant
Designer	Richard Hollant
Illustrator	Richard Hollant
Photographer	Jim Coon
Client	Public Relations Society of America, Connecticut Valley Chapter
Software	QuarkXPress, Adobe Photoshop
Paper	Beckett Expressions, "the best darned digital paper in the world"
Colors	Four, process
Type	Bastard, Ignatius, Karton
Special production technique	Digitally printed

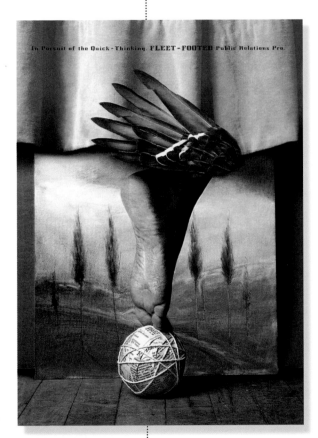

It's a feather plucked from the cap of Mercury.

It's a symbol of speed and articulation --

It's a representation of both the impeccable message and

the determination to deliver that message.

IT'S A CALL FOR ENTRIES

The Mercury Awards recognize outstanding work in the public relations, communications

and marketing fields. Created by the Connecticut Valley Chapter of the Public Relations

Society of America, the awards are designed to honor creative and strategic excellence

and to encourage a higher level of performance among our peers.

102 | 103

"You can't give a philosophy major the assignment to design a call for entry for the Mercury Awards and expect anything that isn't metaphorical," says art director Richard Hollant. Taking a cue from "Quicken, Quicktime and Quick, Quick, Quick everything," Hollant paid homage to the winged messenger of the gods. A collage-style image makes a striking cover. Inside, a beautifully photographed white feather on a scored cardboard background is the perfect foil for a classic type arrangement.

Studio	Chronicle Books
Art Director	Jeremy Stout
Designer	Jeremy Stout
Production Coordinator	Tera Killip
Photographer	Jesse Alexander
Client	Self
Software	QuarkXPress, Adobe Illustrator
Paper	157 gsm matte art
Colors	Three, match
Print Run	10,000
Type	Univers family, Adobe Garamond
Special production technique	The pages had to be laid out to prevent the metallic silver and heavy black from offsetting on facing pages.

The dynamic photographs of one of auto racing's most famous photographers get dynamic treatment in this coffee-table book. Beautifully reproduced as duotones, some with black and silver, the photos are carefully laid out to prevent saturated colors from offsetting on the white space. Large blocks and columns of straight metallic silver added to the technical difficulty but produce a forceful effect.

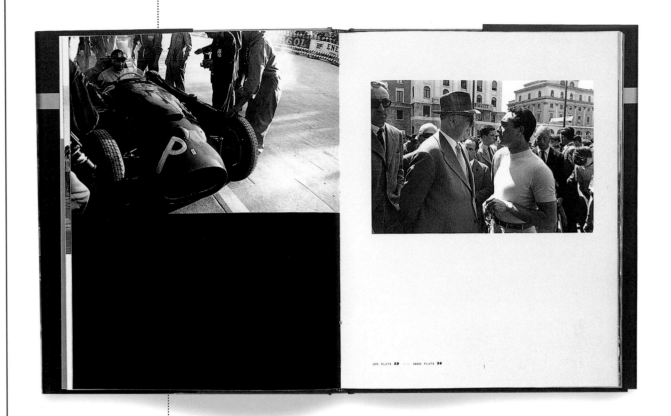

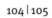
LEFT: PLATE **29** ⋯⋯ ABOVE: PLATE **30**

PLATE **74**

HESSE DESIGNS STUDIOS

SACKETT DESIGN ASSOC.

DESIGNAHOLIX

WEST & VAUGHAN

MURPHY DESIGN

INOX

STUDIO INTERNATIONAL

TOM FOWLER, INC

THAT'S NICE

AIELINSKI DESIGN ASSOCIATES, INC

CHENG DESIGN

AUFULDISH & WARINNER

CURRY

STEVEN BROWER DESIGN

[METAL] STUDIO

MATTHIAS-KARIM AVICE

CHRONICLE BOOKS

PARTICLE

PERNSTEINEN CREATIVE

MASTANDREA DESIGN

ERIC ROINESTAD

LMC STUDIO

chapter 4 **LAYOUT**

1 47 110 00 64 114 56 125 8 3435 87 5768 134 175 8 117 35 6 43 1⁵

Layout is perhaps one of the most underappreci-ated design talents. But if they're not laid out well, the best concepts, type treatments and images are wasted. They'll be overlooked at best, robbed of all their power at worst.

Layout means more than arrangement on a page. It means arrangement of the page—in other words, making the page an integral part of the message. It means uniting disparate design ele-ments into a whole that's greater than the parts.

The following projects are masterfully arranged so that the design elements seem to speak on their own. But good designers know that can never happen. A good look at great layout reveals its power to unleash the potential of all the more visible design elements. Imagine any of these projects laid out like any of the others, and you'll see at once that the message is lost, the power gone.

Studio	Hesse Designstudios GmbH
Art Director	Klaus Hesse
Designers	Kai Bergmann, Markus Bernatzky, Andrea Eiche
Illustrators	Kai Bergmann, Markus Bernatzky, Andrea Eiche
Photographer	Michael Habes
Client	Art Directors Club fuer Deutschland e.v.
Software	QuarkXPress, Adobe Photoshop, Freehand
Paper	PhoeniXmotion xantur, 155 g/qm and 250 g/qm (cover)
Colors	Four-color process plus one match
Print Run	8,000
Type	Futura

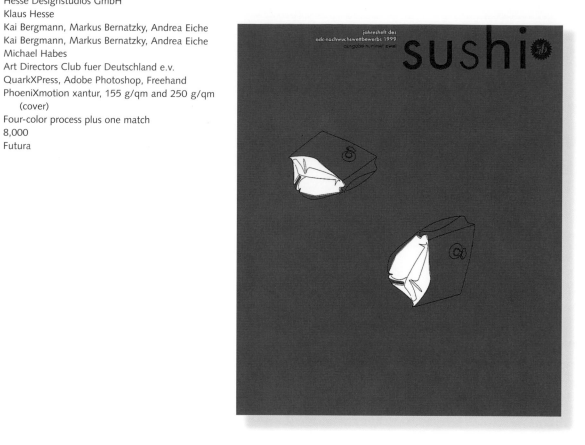

Many different projects and styles are highlighted in this superbly produced book. A glaring match orange cover makes it impossible to lose, even on the most crowded desk. Inside, a strict but versatile grid gives the individual pieces maximum impact. Though ordered, the book is hardly humorless—one all-white spread takes a humorous poke at computer forums, while directing the reader to one.

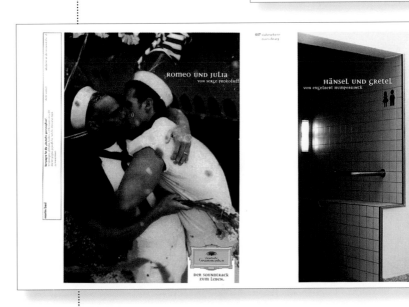

Studio	Sackett Design Associates
Art Director	Mark Sackett
Designers	Wendy Wood, Lisa Fisher, James Sakamoto, George White
Photographer	Robert Cardin
Copywriter	Bill Bisesto
Client/Service	Spark Online/software
Software	Adobe illustrator, Adobe Photoshop, QuarkXPress
Paper	Potlatch McCoy Silk 120# cover (folder), 80# cover (brochure), 100# text (data sheets)
Colors	Four-color process plus two match colors, spot gloss and varnish
Type	Meta, Vitriol, Babymine, Futura
Special feature	Custom die-cut folder

A spectacular custom folder introduces a new product "in a bright, fun way," according to designers. Bold stripes, asymmetrical die-cuts and bright colors entice the reader, and that's just the folder. The brochure itself features bold images, saturated colors and contemporary typefaces all arranged in circles, ovals and irregular columns.

Studio	Designaholix
Art Director	John Jenson
Designers	David and John Jenson
Illustrators	David and John Jenson
Photographers	David and John Jenson
Client	Moloko Shivers band and Fox View Lanes nightclub
Software	Photoshop, Illustrator, QuarkXPress
Colors	Four, process
Print Run	100
Cost Per Unit	$2
Type	Helvetica Compressed, various

"Digital photography and scanning saved us tons," say designers David and John Jenson. Designed in the style of a classic 1960s rock poster, this 11 x 17 inch four-color poster was destined to hang in dorm rooms and the kind of basement lairs featured in Pad *(page 128). The sinister glowing babydoll head provides the perfect graphic for this piece, which begs for a black light.*

Studio	West & Vaughan
Creative Director	Robert Shaw West
Art Director	Rob Baird
Designer	Rob Baird
Illustrators	Michael Gellen (glasses), Mike DelMarMol and Chris Spollen (stickers)
Client/Service	Visix/Software
Software	QuarkXPress, Illustrator
Colors	Four, process
Type	Helvetica
Special feature	Sticker sheet was an insert for trade magazines.

Designed for "individuals united in their hate for advertising," these pieces for a software producer used a little "tomfoolery," says creative director Robert Shaw West. The stickers lets computer users decorate their computers as if they were model cars. The glasses ad suggests a way to get sympathy from the boss. Both give the recipients a present rather than simply asking them to spend money.

Studio | Murphy Design Inc.
Designer | Mark Murphy
Photographer | Eric Rippert
Client/Service | Scott Hull Associates/Illustration representatives
Software | QuarkXPress
Type | Hoefler Text, Champion, Clarendon, Univers
Cost-cutting technique | "Maximized complete live area of press sheet and figured out a unique size to promote 72 pages of content to print on two press sheets."

Bright colors and a mysterious yet heroic action figure create a sense of anticipation for this piece which advertises an illustrators' rep. Designed to reinforce the client's name and get potential users to look at the client's Web site, the ad reveals just enough information to whet the appetite.

Studio	Inox Design
Designer	Renzo Pergher
Illustrator	Renzo Pergher
Photographer	Lorenzo Scaccini
Client/Service	The Caboto Group/investment banking
Software	Photoshop, QuarkXPress
Paper	Fedrigoni Arcoprint
Colors	Five, match
Type	Din, Garamond

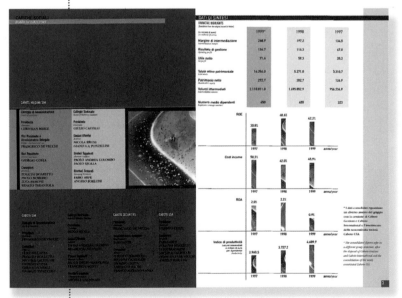

A collection of annual reports for an investment group, this four-volume set comes in a custom slip-case. Each piece features the same image of a glass marble, its swirls printed in different colors. Inside, the marble image is used for innovative bar graphs. Text pages, including copy in both Italian and English, feature color photos, while financials are printed in black and match blue. The color photos have a surreal look; they're printed on a five-color press, but with match colors rather than CMYK inks.

Studio	Tom Fowler, Inc.
Art Director	Thomas G. Fowler
Designers	Karl S. Maruyama, Thomas G. Fowler
Photographers	FPG, Panoramic Images
Client/Service	Herlin Press/printer
Software	QuarkXPress
Paper	100# LOE Gloss
Colors	Four-color process plus one match
Print Run	1,000
Cost Per Unit	$9.84
Type	Franklin Gothic
Special production technique	Direct-to-plate imaging
Special feature	Pop-up graphic
Special type technique	Font expanded 150 percent

114 | 115

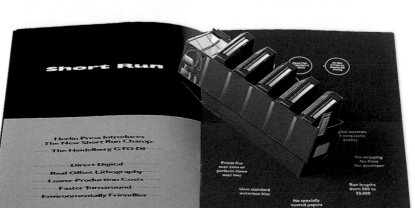

Bold images set off with blocks of glossy black demand attention in this brochure for a printer. Even the ghosted type, expanded 150 percent in width but not in height, communicates the message to "think short." The last spread packs a powerful final graphic punch: A pop-up model of a press insures clients won't forget Herlin's new direct-digital capabilities especially suited to "short" runs.

Studio	Studio International
Art Directors	Petar Selem, Boris Ljubicic
Designer	Boris Ljubicic
Illustrators	Igor Ljubicic, Petar Pavic
Photographers	HRT, Boris Ljubicic
Client/Service	HRT/Croatian radiotelevison
Software	3Ds Max, Photoshop, CorelDraw
Paper	Zanders 170 g matt
Colors	Four, process
Print Run	500
Cost Per Unit	$28
Type	Futura
Special feature	Oversize four-ring binder with printed cover glued on

Photography makes this beautiful graphic standards manual stand out. A ribbon of tiny photo images, some four-color and some one-color, tops every oversize page. Full-color spreads show different graphic effects for television, while line art spreads show the logo (with the key red squares based on the Croatian arms) in myriad uses. Generous white space and artistic touches add elegance.

Studio	"That's Nice"
Art Director	Nigel Walker
Designer	Phil Evans
Photographer	Brian Pierce
Text	Mark Allen
Client	Self
Software	QuarkXPress, Photoshop, Illustrator
Paper	200 gsm Invercote Create Matte (cover); 157 gsm Top Kote Dull A-2 (text); 128 gsm Top Kote Gloss A-2 (photo pages)
Print Run	5,000
Cost Per Unit	$2.25
Special production technique	PUR binding
Special feature	Matte laminate cover
Special cost-cutting technique	Printed in Hong Kong

"Most of our clients want to read," explains "That's Nice" art director Nigel Walker. The first section of this portfolio book has no pictures. Short blocks of text printed in (or ghosted out of) various shades of blue introduce the studio. Narrow vertical bands of dark blue separate blocks of color. In section two, the same dark blue bands (joined by other colors) run throughout an exuberant collection of words and images. "You don't buy design, you buy the designer's inspiration," Walker says. "That section is all personal. It's about what inspires us." In the third section, a colorful array of bands helps arrange a wide variety of work into an orderly presentation.

Studio	Zielinski Design Associates
Art Director	Tom Zielinski
Designers	Tom Zielinski, David Hauck, Kirk Vinson
Illustrator	Kirk Vinson
Photographers	Phil Hollenbeck, Todd Meyers, Danny Hollenbeck
Client	Dallas Society of Visual Communications
Software	QuarkXPress, Photoshop, Illustrator
Paper	Papertech Magno Dull
Colors	One, match
Print Run	2,000
Cost Per Unit	Pro bono
Type	Modula Serif, Regular Joe, Washout, Officina Serif, Anchorette, Avante Garde, others
Special production technique	Black double-bumped for better coverage
Special feature	All books wrapped in cellophane

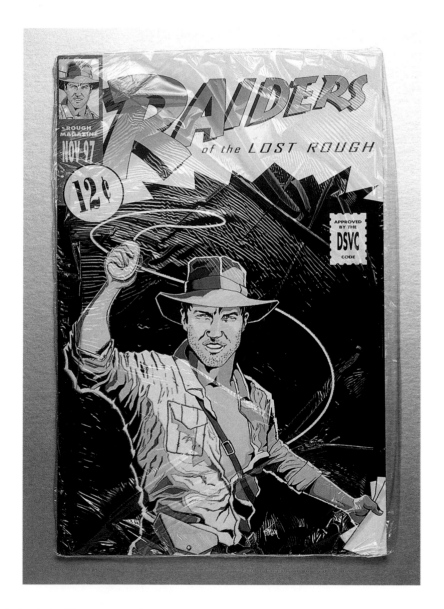

The kind of publication every design organization wished it produced, this issue of Rough contains a variety of intriguing articles and artwork presented so imaginatively that you can't put it down. Bagged like a collectible comic book, the 9" x 14" publication boasts premium illustrations and photos, clear but unique layout and even a photo comic strip that's actually funny. Double-bumping most of the black gives the piece an extra rich look.

Gallery

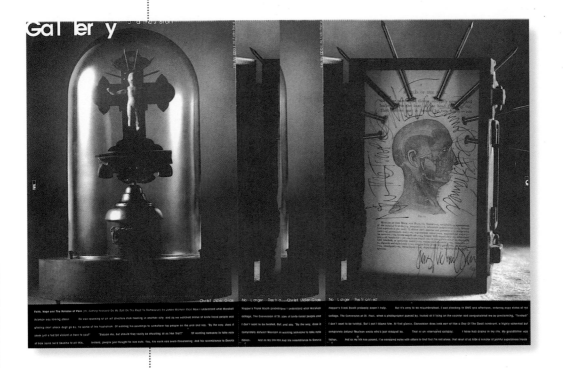

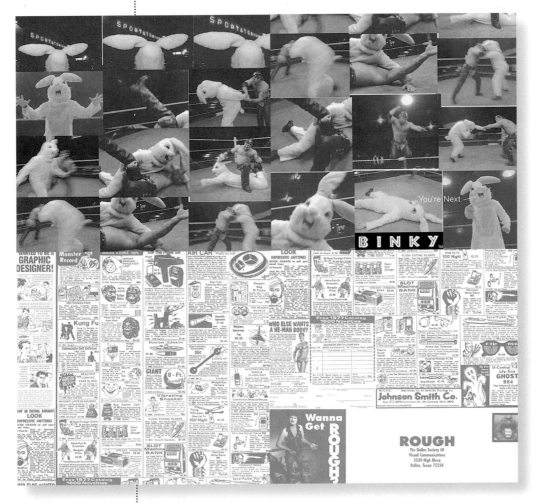

Studio	Cheng Design
Designer	Karen Cheng
Photographer	Richard Nichol
Client	University of Washington School of Art
Software	QuarkXPress, Adobe Photoshop
Paper	Lustro Archival Dull 80# cover and text
Colors	Match black (cover), Four-color process (text); aqueous coating
Print Run	1,000
Cost Per Unit	$1.10
Type	Trade Gothic, Centaur
Special fold	French-fold cover
Special production technique	Perfect bound

A showcase for the university's Class of 2000 graduates, this piece balances photography and type with understated elegance. The French-fold cover highlights the artists' names in spare type, while the four-color interior floats photographs of disparate artworks in alternating black-and-white backgrounds. An overall aqueous coating adds luster. The narrow spine made perfect binding a challenge, which designer Karen Cheng solved by locating a bindery with particularly accurate equipment.

Studio	Aufuldish & Warriner
Art Director	Bob Aufuldish
Designer	Bob Aufuldish
Photographer	Bob Aufuldish
Client	California College of Arts and Crafts
Software	Illustrator, Photoshop, QuarkXPress
Paper	Finch Opaque Vellum Cover, French Frostone 80# Text (add///drop///add)
Colors	Two, match with black
Type	Interstate (by Tobias Frere-Jones), Century Schoolbook (by M.F. Benton), VAG Rounded, Vendetta (by John Downer), Mrs. Eaves (by Zuzana Licko), Scala (by Martin Majoor), Bell Gothic (by C.H. Griffith)
Cost-cutting technique	All are self-mailers.

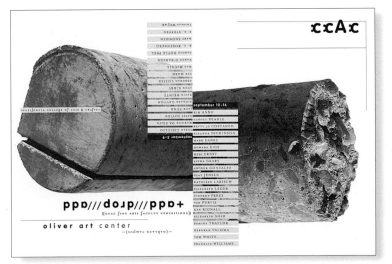

Though each of these pieces for an arts and crafts college has a different look, all share the same design sensibility. Using one or two colors and simple but intriguing images, art director Bob Aufuldish communicates a modern attitude toward age-old crafts. Artful type treatments allow a lot of information to be presented clearly in a small space.

Studio	Curry Design Associates
Art Director	Jason Scheideman
Designers	Jason Scheideman, Pyong Mun, Christine Ragaini, Debbie Kawamoto, Chancie Garnin
Photographer	Marcelo Coelho
Clients	Self, B&B House of Printing, Marcelo Coleho Photography, Nationwide Printers
Software	QuarkXPress, Photoshop, Illustrator
Paper	Potlatch McCoy Silk, Glama Natural Prisms, Mohawk Superfine, Wausau Royal Silk Natural, Fraser Pegasus Midnight Black
Colors	Four-color process plus two match colors, match silver, varnish
Print Run	1,200
Cost Per Unit	$20
Type	Bauer Bodoni, Poetica, Univers, Frutiger, Adobe Garamond, Mrs. Eaves, Univers, Caslon, New Century Schoolbook, Akzidenz Grotesk, Kuenstler Script, Democratica, Smargard
Special production technique	Double-hit of silver on front cover
Special feature	Spiral binding

Four designers each worked on a section of this weekly calendar inspired by musicians. While each section reveals a different design sensibility, the piece has a united look created by its lavish use of chartreuse metallic silver ink and its overall clear, easy-to-use structure. Fine coated papers, black mat-board covers, die-cut dividers, extra-wide spiral binding and other tactile touches make this piece a delight to touch as well as look at.

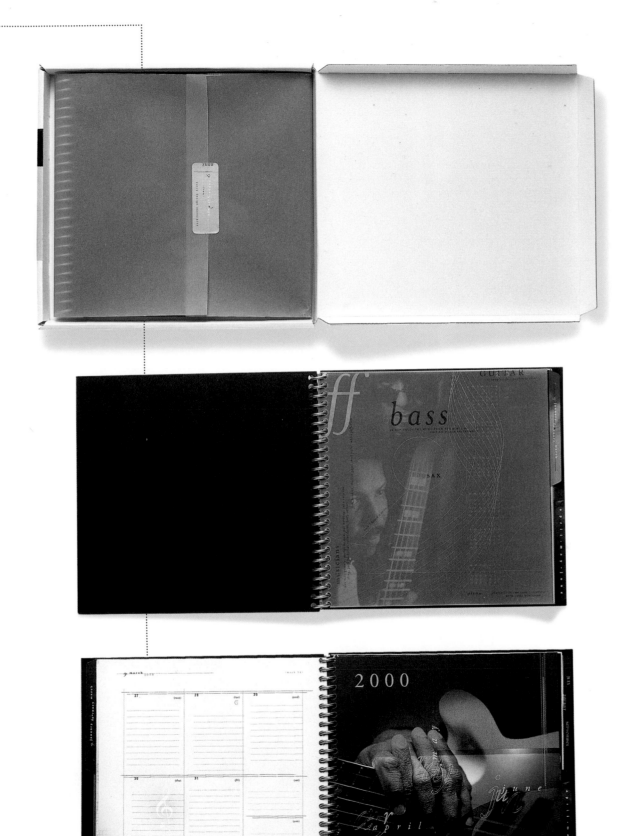

Studio	Steven Brower Design
Art Director	Steven Brower
Designers	Steven Brower and Ben Wundersitz (Jan/Feb 2000), Steven Brower
Henna Artist	Makiko Yoshimura
Photographers	Ben Wundersitz (Jan/Feb 2000), Melissa Hayden (March/April 2000), Barnaby Hall (May/June 2000)
Client	Print Magazine
Software	QuarkXPress, Illustrator, Photoshop
Paper	Sterling
Colors	Four-color process plus one match (Jan/Feb 2000 and May/June 2000) and matte varnish
Type	Various

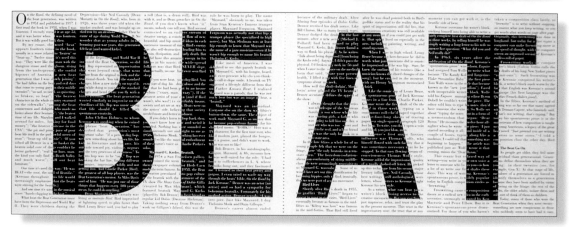

When designer Steven Brower gave Print *magazine its first major redesign in 30 years, his first issue was the annual student cover contest. The winner proved to be a perfect launch for the new masthead. "I fought hard during the judging to have this cover win," says Brower. "I liked its sense of humor. And it featured elements from the old cover format, so I thought it was a nice way to bid farewell to the past." By the third cover, Brower was ready to experiment with a hand-rendered version stenciled in henna. "Now the hard part," he remembers. "Finding a model ..."*

Studio	[metal] Studio Inc.
Art Director	Peat Jariya
Designer	Shad Lindo
Client/Service	GCA/wastewater management
Software	Pagemaker, Photoshop, Illustrator
Paper	Canson Satin #27 Pearl (jacket), Mohawk Navajo Brilliant White #80 cover (cover) and #80 text (text)
Colors	Match black plus tinted varnish (jacket), four-color process (cover), two match (text)
Print Run	2,600
Cost Per Unit	$10
Type	bubbledot (headers), Eurostyle (text)
Special production techniques	Tinted varnish, stitched-in jacket
Special feature	Wraparound vellum jacket

To celebrate the client's 30th anniversary—traditionally the "pearl" anniversary—[metal] created an annual report with a wraparound jacked of pearlescent vellum. The vellum's semitransparent sheen gives the piece mystery and elegance, softening the four-color image and providing the perfect surface for printing in tinted varnish. Text pages are printed in two colors to offset the cover's expenses.

Studio	Curry Design Associates
Art Director	Steve Curry
Designer	Chancie Garnin
Client/Service	Universal Studios/films and syndicated television programming
Software	Photoshop, Illustrator, QuarkXPress
Paper	McCoy Silk
Colors	Four, process
Print Run	1,500
Cost Per Unit	$25
Type	Univers
Special production techniques	Dry varnish, blind embossing, spiral binding, die-cut pages
Special feature	Cover is French-folded for added weight

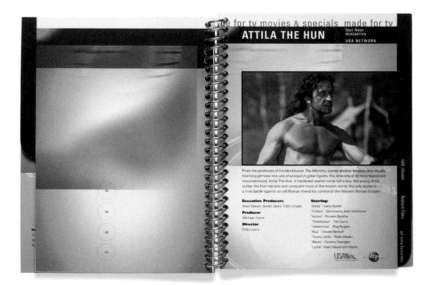

Thick metal for the spiral binding and French-folded covers give this brochure extra heft—a nice touch for a booklet weighing in with stats and descriptions for Universal Television's entire lineup of shows. Tabs make it easy to flip from "Current Series," such as Cleopatra 2525 and Jack of All Trades to "Made for TV Movies/Specials" like Attila the Hun.

Art Director	Matthias-Karim Avice
Designer	Matthias-Karim Avice
Photographer	Léo
Client/Service	Baco/musician
Software	Photoshop, QuarkXPress
Paper	Couché Moderne Royal Prestige Gloss
Colors	Two, match
Print Run	1,000
Cost Per Unit	200 francs
Type	Din

A simple layout of textures and photos gives this CD an elegant look without a lot of bells and whistles. The artist's photo is featured on the front and back covers, laid over a textured photo reminiscent of an old leather book cover and printed on the CD itself. Inside, short blocks of text and tiny performance photos dot the same textured photo, printed in a different color.

Studio	Chronicle Books
Art Director	Shawn Hazen
Designer	Shawn Hazen
Illustrator	Susan Tudor
Photographer	Jack Gould
Client	Self
Software	QuarkXPress, Illustrator, Photoshop
Paper	157 gsm Japanese matte art (text), 116 gsm Leathac Red (cover)
Colors	Four, process (text); match black (cover)
Print Run	20,000
Type	Corpus Gothic Alternative (by Peter Bruhn), Trade Gothic family (by Jackson Burke), Century Schoolbook (by Morris Fuller Benton)
Special features	Cover features die-cuts and foil stamping

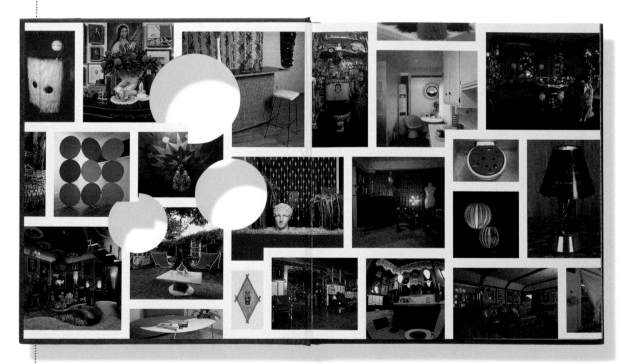

Designed for people whose taste in home decor is a far cry from Martha Stewart's, Pad *celebrates exuberance and kitsch. The lurid red die-cut cover features gloss black foil stamping and a "whiz-bang mirrored pattern foil" that heralds what's to come. "It wasn't the cheapest book in the world to produce," says art director Shawn Hazen. "I had some fun on the interior with overprinting the black chapter numbers on the colored background. And though four-color end pages are usually considered a little extravagant, they (along with the die-cuts) were a sneaky way to get color onto a cover with so many bells and whistles."*

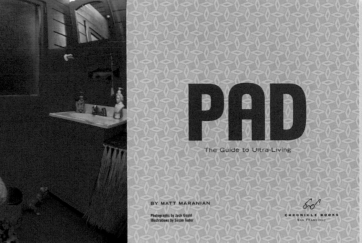

PAD

The Guide to Ultra-Living

BY MATT MARANIAN

Photographs by Jack Gould
Illustrations by Susan Tudor

CHRONICLE BOOKS
SAN FRANCISCO

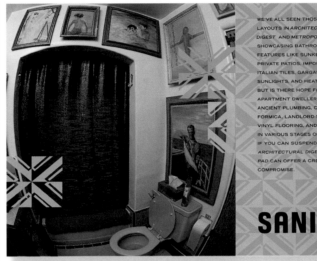

WE'VE ALL SEEN THOSE BEAUTIFUL
LAYOUTS IN *ARCHITECTURAL
DIGEST* AND *METROPOLITAN HOME*
SHOWCASING BATHROOMS WITH
FEATURES LIKE SUNKEN TUBS,
PRIVATE PATIOS, IMPORTED MARBLE,
ITALIAN TILES, GARGANTUAN
SUNLIGHTS, AND HEATED FLOORS.
BUT IS THERE HOPE FOR THE
APARTMENT DWELLER WHO HAS
ANCIENT PLUMBING, CHIPPED
FORMICA, LANDLORD-SELECTED
VINYL FLOORING, AND WALLS
IN VARIOUS STAGES OF DRY ROT?
IF YOU CAN SUSPEND THE
ARCHITECTURAL DIGEST FANTASY,
PAD CAN OFFER A CREATIVE
COMPROMISE.

4

SANITARY PAD

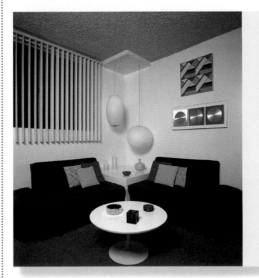

PAD PROFILE: JOHNNY FOAM

"MY home is my way of expressing and reveling in my collections and my obsessions—and I'm oozing with expression. I have oozed all over anyone who has ever known me," asserts customer Johnny Foam. "And I'm not done."

Johnny has created a home built from two pasts: his childhood vision of adulthood and a culture's outmoded vision of its future. It's a postmodern trip through yesterday's world of tomorrow, a playground of glowing orbs, white gravel gardens, and molded plastics, all held together with an obsessively restricted color palette of the basics: red, blue, white, green, and yellow.

"My home has always been ever-evolving, and what it's evolved into now is a complete fantasy," Johnny says. "It actually started in the '70s when I was just getting out of high school. I started collecting deco, and that evolved into the atomic '50s and then the space-age '60s, and I

ended up keeping only the most futuristic pieces from all of those periods. When I started collecting molded plastic furniture and what I'm living with now, I realized, as the concept was coming together and nearly complete, that I had created this sort of *Playboy* bachelor pad that my childhood self thought was a truly happening, successful adult lived. And I guess now I'm a truly happening, successful adult."

Creating this fantasy pad in a modest one-bedroom apartment was not without its challenges and obstacles. For starters, a radiant heating system prevents Johnny from drilling any holes in the ceiling, which required a clever Plan B to hang six George Nelson bubble lamps. Oddly enough, by working around this he created one of the apartment's most interesting and subtle details: the "light box" from which two of the fixtures hang. "I built a lightweight wood frame and anchored it into the wall

Studio	Particle
Art Directors	Chris Noel, John Foster
Designer	John Foster
Illustrator	Randy Lyhus
Client	Art Directors Club of Metropolitan Washington
Software	QuarkXPress, Photoshop, Illustrator
Paper	Fox River Starwhite Tiara Smooth
Colors	Four, process
Print Run	2,000
Cost Per Unit	donated
Type	Adobe Garamond, Marigold, Base Nine
Special production technique	"Grid pattern produced by printing .5 pt. lines on the cyan plate at 100 percent"
Special type technique	Marigold face digitally manipulated

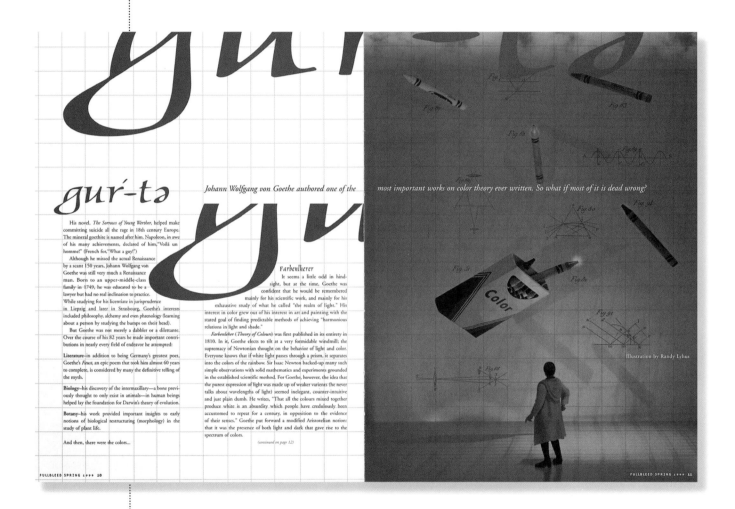

An intriguing full-page illustration and a full-page type treatment play against each other in this spread from Full Bleed *magazine. The article explores Goethe's insightful, but wrong, 19th-century color theories. Randy Lyhus provided the illustration free simply for the chance to try something new. "The starting point for the illustration is actually a photograph with a* Star Wars *figure in the center," says designer John Foster. "Very different from his usual work and absolutely perfect for the piece."*

Studio	Pernsteiner Creative Group, Inc.
Art Director	Todd S. Pernsteiner
Designer	Todd S. Pernsteiner
Photographers	William Rideg, Lynn Rogers, Sharon Haller, Photodisc Inc.
Client/Service	International Wolf Center/preservation of wolves
Software	Illustrator, PageMaker, Photoshop
Paper	Wausau Royal Fiber (annual report), Driftwood Seal (gold seal)
Colors	Two match (annual report), match black (seal)
Print Run	1,000
Type	Garamond Book and Leawood Italic (headlines), Futura Bold (subheads), Futura Book and Bold, Garamond Italic (text)
Special features	Die-cut self mailer/cover, stepped pages in annual report
Special cost-cutting technique	Design for reuse

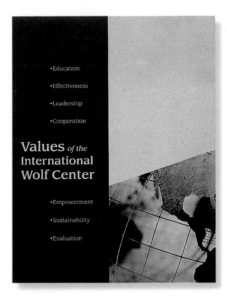

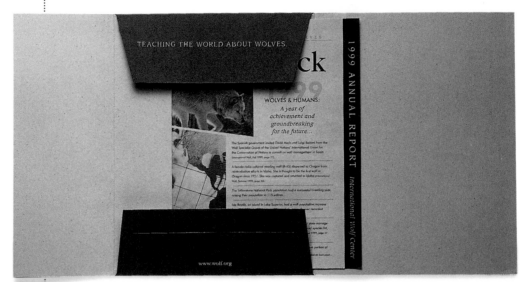

The annual report for this international organization dedicated to preserving wolves gets the look of an expensive piece by clever choice of color and shape. Distinctive ink colors on brown stock deliver a high-end look on a two-color budget. Stepped pages add more interest without much cost. "We worked with the client to determine what additional print collateral needs they had," says art director Todd Pernsteiner. The result was a custom folder and gold seals that could be used on many other projects.

Studio	West & Vaughan
Creative Director	Robert Shaw West
Art Directors	Robert Shaw West, Rob Baird
Designer	Rob Baird
Illustrator	Mike DelMarMol
Client/Service	Coffee Underground/coffee shops
Software	QuarkXPress, Illustrator
Colors	Two, match
Print Run	1,000
Cost Per Unit	$2
Type	Franklin Gothic

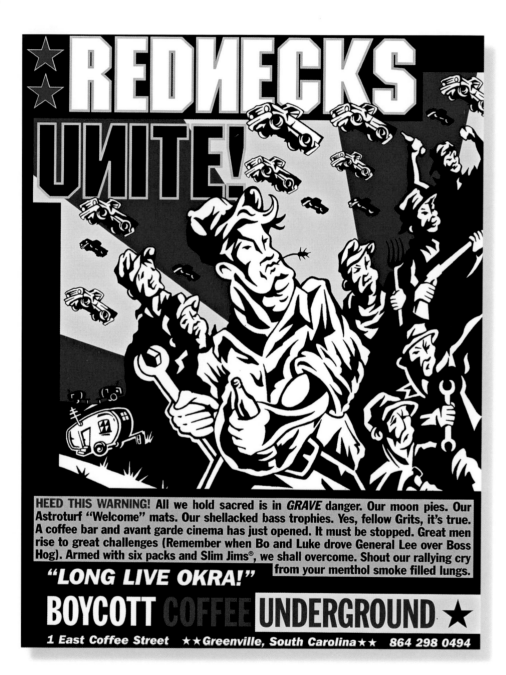

Coffee Underground, a small chain of "avant garde coffee shops" whose target is towns too small for Starbucks, wanted a way to attract attention quickly. Posters inspired by Russian Communist propaganda hit just the right note. "The sniping posters were used as a PR tool during grand openings," says creative director Robert Shaw West. "It was a cost-effective way to create a brand in 'redneck' towns. And so I don't get a ton of angry rednecks calling, let me preface that by saying…it's a joke!"

Studio	Mastandrea Design, Inc.
Creative Director	Dennis Crowe
Art Director	Anderson Gin
Designer	MaryAnne Mastandrea
Client/Service	Levi Strauss & Co./clothing
Software	QuarkXPress, Adobe Illustrator, Adobe Photoshop
Paper	Frosted plastic (binder), Lustro Dull Cover (text)
Colors	Three match (cover), four-color process plus three spot match
Special production techniques	Screenprinted, frosted plastic binder; die-cut pages

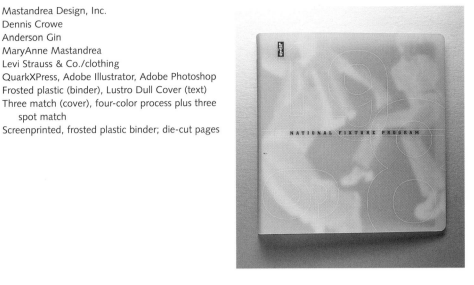

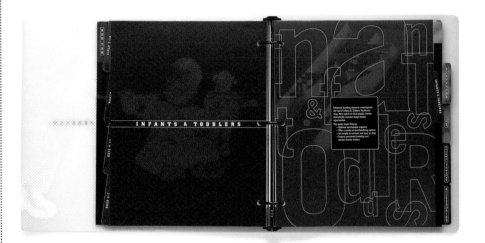

132|133

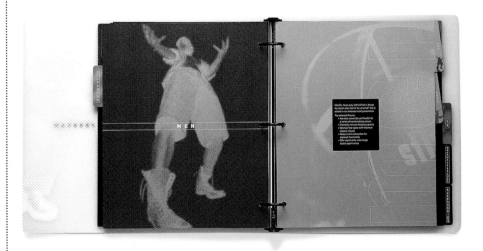

A screenprinted, frosted plastic binder gives this fixtures manual a distinctive look. Inside, bold red, orange and black pages create an instant feeling of confidence and purpose. An exciting combination of overlapping type and photos reproduced in giant dot screens communicates excitement and vision. "The challenge was to design a clear, easy-to-use product presentation, yet give it visual excitement and energy," says designer MaryAnne Mastandrea.

Studio : Flaunt Magazine/Eric Roinestad Design

Art Directors : Eric Roinestad (cover), Eric Roinestad and Jim Turner (spreads), Andres Serrano (fashion spreads)

Designer : Eric Roinestad

Fashion Editor : Long Nguyen

Photographers : David LaChapelle (cover), Nils (New York celebrity shots), Larry Hammerness (Los Angeles celebrity shots)

Client : Flaunt magazine

Software : Adobe Photoshop, QuarkXPress

Colors : Four, process

Print Run : 90,000

Type : Din Regular, Medium and Light (by Albert-Jan Pool), LED, Meta Normal and Black (by Erik Spiekermann)

Special production techniques : Half-circle die-cut and embossing on cover

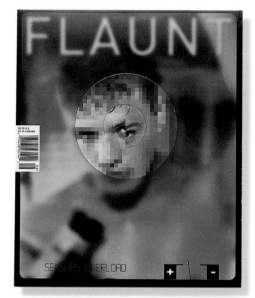

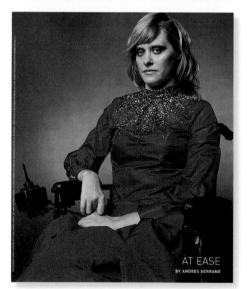

Flaunt's ambiguous attitude toward celebrity and money is revealed in its layouts. Here, the die-cut cover focuses an imaginary lens on actor Ryan Phillippe. Filmstrip-style celebrity photos on the "paparazzi" page are nearly as small as I-Zone prints, and fashion shoots include a woman in a wheelchair, who has mastered the professional model's stare.

Studio	Particle
Art Director	John Foster
Designer	John Foster
Photographer	Tina Williams
Client	The Art Directors Club of Metropolitan Washington
Software	QuarkXPress, Adobe Illustrator, Adobe Photoshop
Paper	Fox River Confetti
Colors	Two match plus laser printing
Print Run	3,000 postcards, 500 programs
Cost	$250 total
Type	Trade Gothic, Grunge

134 | 135

A photograph of a toy robot, produced in halftones and printed in metallic silver on red paper, creates an intriguing look for an annual student competition. Both pieces were printed two months before the show. "A few days before the reception, the programs were run through a laser printer, then hand-scored and folded," says art director John Foster. "Due to the tight timeframe, the pieces were not just pro bono, they were completed outside of studio hours."

Studio	Chronicle Books
Art Director	Jeremy Stout
Designer	Jeremy Stout
Production Coordinator	Tara Killip
Illustrator	Jeremy Stout
Photographers	Tony Armour Photography, Joshua Dunn
Client	Self
Software	QuarkXPress, Illustrator
Paper	118 gsm Lynx Vellum
Colors	Four, process
Print Run	17,500
Type	Helvetica Neue Book, Condensed and Bold Outline; Century Old Style and Expanded; ITC Century Book and Condensed; Adobe Garamond; Adobe Garamond Expert
Special production technique	Holographic cover

A beautiful look at the history and art of currency, this book takes its design cues from money around the world. Art director Jeremy Stout took cues from bills and used engraving patterns, bright colors, colored bars and money-inspired layouts throughout the book. The cover sets the tone. "We matte laminated the cover and then hit it with a Crown foil across the entire piece," says Stout. "The foil is holographic, like the metallic strips in many currencies."

FIGURE 21

It's fitting that this portrait of Norwegian author Sigrid Undset appears against a stylized medieval tapestry, and that the holographic ribbon running down the right is drawn from wood-carving motifs from Norway's eleventh-century Urnes church. Her masterpiece, the trilogy *Kristin Lavransdatter*, published 1920–22, is a medieval epic. Undset won the Nobel Prize in 1928, and became *so personally* medieval that in later years she lived in a house restored to its authentic A.D. 1000 prime, and dressed in the ancient style of a Norse matron.

FIGURE 22

No, it's not Benjamin Franklin's sister. This is Mary Reibey, an early settler in Australia—if involuntarily so—and a true rags-to-riches story. Born in England in 1777, both her parents died when she was young.

She was made an indentured servant, ran away at fourteen, stole a horse, got caught, and was "transported" to New South Wales. At seventeen, she married Thomas Reibey, who went on to found an extremely successful shipping business extending to India and China. When he died in 1811, she took over, raising their seven children alone, further expanding the business and buying considerable property in Sydney. At her death in 1855, the ex-convict waif was one of the wealthiest people in Australia.

FIGURE 23

Golda Meir led a life committed to the founding, and then the preservation, of the state of Israel. Born in Kiev in 1898, she moved with her family to Milwaukee, Wisconsin, when she was eight. As a teenager she became a leader in Milwaukee's Labor Zionist Party. She married and moved to Palestine in 1921, continuing her efforts through

World War II, becoming a signer of Israel's declaration of independence in 1948 and its first ambassador to Moscow. She was appointed foreign minister in 1956, and elected prime minister in 1969, serving until her retirement in 1974.

FIGURE 24A & 24B

Her face quietly beams a deep tranquil sympathy and warm understanding (figure 24A), and her students, on the back (figure 24B), seem peacefully absorbed in their tasks. She is, of course, Maria Montessori, the turn-of-the-century Italian educator whose theories of early education emphasized the creative potential of children and the importance of treating them as true individuals. There must be something to it. Today hundreds of Montessori schools are in operation all over the world.

INTERNATIONAL ZOO

Welcome to The International Zoo. Representations of creatures are yet another way that countries express their special individuality on their money. And these constitute some of the most visually appealing bills of all. Images of birds are far and away the most common. Over two hundred different species turn up on an even greater number of notes. Many are the exotics indigenous to particular places; but since birds are international travelers, a number of the same species appear on money from countries thousands of miles apart. And not only the flashy, hey-look-how-pretty-*I*-am birds—a few countries are downhome and democratic enough to feature the more prosaic plain-lookers that are part of their everyday life.

After birds come animals that are signature species for various places. On African money, for instance, and not surprisingly, there's a whole safari's-worth of lions, elephants, giraffes, gorillas, rhinos, zebras, and so on. In Asia, it's mainly elephants and tigers. Favoring these goes back to the early days of coinage itself, when creatures symbolic of great power were often represented. A definite prejudice toward the warm-blooded exists on money, but nevertheless a few psychedelic tropical fish, colorful lizards, and the occasional turtle do put in an appearance. And a handful of bills even feature *bugs!*

The note at right (figure 1), from Madagascar, is quintessential. Madagascar has one of the most wonderfully weird ecologies in the world, and this note, with its lemur, great blue heron, tortoise, and butterfly, plus the botanical garden in the background, says that loud and proud.

Studio	LMC Studio
Art Director	Monica Hickey
Designer	Lisa Sarkees
Client/Service	Celtic Fusion/dance troupe
Software	Photoshop, QuarkXPress, Illustrator
Paper	Lucent 36 lb. Vellum Text (overlays), Utiopia 1 Dull Cover
Colors	Four-color process plus dull varnish
Print Run	1,000
Cost Per Unit	$10
Type	Emigre Dead History and Emigre Matrix
Special production techniques	Die-cut folder, Wire-O binding
Special cost-cutting technique	Short binding, video stills for images

Angled pages, sliced inexpensively rather than die-cut, invite the recipient to open the pages of this brochure for a new Celtic dance troupe. Vellum overlays, contemporary fonts and layered imagery create a dynamic look and help hide the low resolution of the images. "Because the stills were only 72 dpi, we used bright colors and distortion to maximize their visual appeal," say partners Lisa Sarkees and Monica Hickey.

p. 12 © 1999 White Gas
p. 14 © 2001 Inox Design s.c.r.l.
p. 16 © 2001 Particle
p. 17 © 2001 CO:LAB
p. 18 © *Flaunt* Magazine
p. 21 © 2001 Inox Design s.c.r.l.
p. 22 © Peter Schmidt Studios
p. 24 © Studio International
p. 26 © 2001 Sunspots Creative, Inc.
p. 27 © Tayburn Design
p. 28 © 2001 Inox Design s.c.r.l.
p. 30 © Lewis Moberly
p. 32 © 2000 California College of Arts and Design
p. 33 © 1998 Mastandrea Design, Inc.
p. 34 © Dee&Alison Graphic Inc.
p. 36 © 2001 StudioNorth
p. 37 © 2001 Sunspots Creative, Inc.
p. 38 © 2001 iridium marketing + design
p. 40 © Louey/Rubino Design Group
p. 44 © 1999 Maddock Douglas Inc.
p. 45 © 2000 Erwing Zinger graphic design
p. 46 © Tayburn Design
p. 47 © 2000 fontBoy
p. 48 © 1998 Erwin Zinger graphic design
p. 49 © 2001 Particle
p. 50 © West & Vaughan
p. 51 © George Tscherny, Inc.
p. 52 © 2000 Peg Faimon Design
p. 53 © West & Vaughan
p. 54 © 2001 Boelts Bros.
p. 55 © Y Design
p. 56 © Erwin Zinger graphic design
p. 57 © 2000 Cognito Films
p. 58 © West & Vaughan
p. 60 © Firehouse 101 Art + Design
p. 61 © 2000 CO:LAB
p. 62 © 2000 Matthias-Karim Avice
p. 63 © [i]e design
p. 64 © 2001 CDA/Curry Design Associates
p. 65 © 2000 BK Design Group
p. 66 © 1999 Central Puget Sound Regional
 Transit Authority
p. 67 © Maurio Aurelio
p. 68 © D Zone
p. 69 © 1999 Applied Materials Inc.
p. 70 © 2000 Nielinger & Rohsiepe
p. 71 © 2000 College Entrance Examination Board
p. 72 © 2001 StudioNorth
p. 73 © Firehouse 101 Art + Design
p. 76 © Murphy Design Inc.
p. 77 © 1999 Crave Entertainment
p. 78 © 1999 slow HEARTH studio; © 2000, slow
 HEARTH studio
p. 79 © 2000 Chronicle Books
p. 80 © 1999 *Flaunt* Magazine
p. 82 © 1995 and 1996, Haymarket Trade &
 Leisure Publications
p. 83 © West & Vaughan
p. 84 © 2000 Cartoon Network; the logo JOHNNY
 BRAVO and all related characters and elements
 are trademarks of Cartoon Network © 2000
p. 85 © 2000, CTV/Matthais-Karim Avice
p. 86 © Hesse Designstudios GmbH
p. 87 © West & Vaughan
p. 88 © 2000 and 2001 *Dwell* Magazine
p. 91 © Y Design

p. 92 © Maurio Aurelio
p. 93 © 2001 Murphy Design Inc.
p. 94 © 2000 *The Observer Magazine*
p. 96 © George Tscherny
p. 97 © Firehouse 101 Art + Design
p. 98 © 1999 Murphy Design Inc.
p. 99 © 2000 Association of Photographers
p. 100 © 2000 Designaholix
p. 101 © 2000 Prototype 21
p. 102 © 1999 Georgia-Pacific Papers
p. 103 © 2000 CO:LAB
p. 104 © 2000 Jesse Alexander
p. 108 © 1999 Art Directors Club
p. 110 © 1999 Spark Online
p. 111 © 1995 Designaholix
p. 112 © West & Vaughan
p. 113 © Murphy Design Inc.
p. 114 © 2001 Inox Design s.c.r.l.
p. 115 © 1994 Herlin Press, Inc.
p. 116 © 2000 HRT/Boris Ljubicic, Studio
 International
p. 117 © 2001 "That's Nice"
p. 118 © 1997 Zielinski Design Associates, Inc.
p. 120 © 2000 Cheng Design
p. 121 © 1998 and 2000, California College of
 Arts and Crafts
p. 122 © 2001 CDA/Curry Design Associates
p. 124 © 2000, Steven Brower
p. 125 © [metal] Studio Inc., Houston
p. 126 © CDA/Curry Design Associates
p. 127 © Matthias-Karim Avice
p. 128 © 2000 Chronicle Books LLC
p. 130 © 2001 Particle
p. 131 © 1999 International Wolf Center
p. 132 © West & Vaughan
p. 133 ® 1998 Vehicle/Levi Strauss & Co.
p. 134 © 2000 *Flaunt* Magazine
p. 135 © 2001 Particle
p. 136 © 2000 David Standish
p. 138 © 1999 and 2000 Celticfusion

Aufuldish & Warriner
183 the Alameda
San Anselmo, CA 94960

Maurio Aurelio & Associates
R. Eng. Ezequiel Campos
159-1
Oporto 4100-231
Portugal

Matthias-Karim Avice
Graphiste
62 bis
rue d'Aubervilliers
75109 Paris
France

BK Design Group
109 Melvin St.
Destin, FL 32541

Bernhardt Fudyma Design
Group
133 East 36th Str.
New York, NY 10016

La Boite a Lettres
see Matthias-Karim Avice

Boelts Bros. + Associates
913 11th Street
Golden, CO 80401

Steven Brower Design
164 Rutledge Court North
Matawan, NJ 07747

Cartoon Network TCS
1050 Techwood Drive
Atlanta, GA 30318

Chase Design Associates
2255 Bancroft Avenue
Los Angeles, CA 90039

Cheng Design
505 14th Avenue East
#301
Seattle, Washington 98112

Chronicle Books
85 Second Street
San Francisco, CA 94105

CO:LAB
56 Arbor Street
Hartford, CT 06106

Curry Design, Inc.
1501 Main Street
Venice, CA 90201

Dee&Alison Graphic Inc.
#1902.1-3-4
Daiba Minato-ku
Tokyo 135-0091
Japan

Designaholix
1114 S. Waterville Rd.
Oconomowoc, WI
53066-9258

Dwell Magazine
99 Osgood Place
San Francisco, CA 94133

Peg Faimon Design
725 High Meadow Lane
Oxford, Ohio 45056

Firehouse 101 Art + Design
641 North High Street S.
106
Columbus, OH 43215

Flaunt Magazine
645½ S. Ringeley Drive
Los Angeles, CA 90036

Wayne Ford
22 Chalford Avenue
Swindon, Wiltshire SN3
3NS
United Kingdom

Tom Fowler, inc.
111 Westport Avenue
Norwalk, CT 06851

Gee + Chung Design
38 Bryant Street, Suite 100
San Francisco, CA 94105

Hesse Designstudios GmbH
Duesseldorfer Str.
16 Erkrath NRW 40699
Germany

[i]e design
13039 Ventura Blvd.
Studio City, CA 91604

Iconologic
40 Inwood Circle
Atlanta, GA 30309

iridium marketing + design
134 St. Paul Street
Ottowa, ON KIL 8E4
Canada

Inox Design
11 Via Terraggio
Milano 20123
Italy

Lewis Moberly
33 Gresse Street
London W1P 2LP
England

Lisa and Monica Creatives
Studio (LMC Studio)
903 Moana Drive
San Diego, CA 92106

Louey/Rubino
2525 Main Street
Suite 204
Santa Monica, CA 90405

Maddock Douglas, Inc.
257 N. West Ave.
Suite 201
Elmhurst, IL 60126

Mastandrea Design, Inc.
650 Second Street
Suite 603
San Francisco, CA 94107
also:
12711 Ventura Blvd.
Suite 315
Studio City, CA 91604

[metal] Studio Inc.
1210 W. Clay, Suite 17
Houston, TX 77019

Murphy Design Inc.
434 South 1st Street
San Jose, CA 95113

Nielinger & Rohsiepe
 Pulver Str. 25
 Bochum 44869
 Germany

Particle
 1010 Rockville Pike, Suite
 400
 Rockville, MD 20852

Pernsteiner Creative
Group, Inc.
 574 Prairie Center Drive
 #135-283
 Eden Prairie, MN 55344

Prototype 21
 Unit 23
 Liddell Road
 London NW6 2EW
 United Kingdom

Eric Roinestad Design
 645½ S. Ringeley Drive
 Los Angeles, CA 90036

Sackett Design Associates
 2103 Scott Street
 San Francisco, CA 94115

Peter Schmidt Studios
 Feldbrunnestrasse 27
 Hamburg 20148
 Germany

Slow HEARTH Studio
 295 6th Avenue
 Brooklyn, NY 11215

Sound Transit
 401 South Jackson Street
 Seattle, WA 98104-2826

Studio International
 Buconjiceva 43
 Zagreb, HR-10 000
 Croatia

StudioNorth
 1616 Green Bay Road
 North Chicago, IL 60045

Sunspots Creative, Inc.
 51 Newark Street
 Suite 205
 Hoboken, NJ 07030

Tayburn Design
 15 Kittle Yards
 Causewayside
 Edinburgh EH9 IPJ
 United Kingdom

That's Nice
 18 West 27th Street
 Ninth Floor
 New York, NY
 10001-6904

George Tscherny, Inc.
 238 East 72 Street
 New York, NY 10021

West & Vaughan
 One Peabody Place
 112 South Duke Street
 Durham, NC 27701

White Gas
 408 Duncan Drive
 San Marcos, TX 78666

Y Design
 78 Manhattan Ave. #1B
 New York, NY 10025

Zielinski Design Associates
 6301 Gaston Avenue #820
 Dallas, TX 75214

Erwin Zinger Graphic Design
 Bunnemaheerd 68
 Groningen 9737RE
 Netherlands

More essential
Resources
FROM **HOW**
DESIGN BOOKS

➡ With deadlines looming, you can't always wait for inspiration to strike. Sometimes you have to go out and find it. That's where *Idea Index* comes in. Inside this pocket-sized powerhouse you'll discover thousands of ideas for graphic effects and type treatments—via hundreds of prompts designed to stimulate and expand your creative thinking. Use *Idea Index* to brainstorm ideas, explore different approaches to your work and stir up some creative genius when you need it most.

ISBN 1-58180-046-0, paperback w/vinyl cover, 312 pages, #31635-K

➡ Nothing is more exciting than an unusual design challenge, but where do you begin if it's something you've never designed before? Relax. *Creative Solutions for Unusual Projects* has all the resources and design expertise you need to solve any design emergency. You'll find start-to-finish solutions for everything from funky brochures to out-of-the-ordinary packaging to larger-than-life projects. Each project includes templates, quick fixes and gritty solutions so you can design each one with professionalism and style.

ISBN 1-58180-120-3, paperback with flaps, 192 pages, #31816-K

➡ Create great letterhead and business card designs that effectively showcase your—or your client's—business, services and market position at a glance. Fresh, contemporary examples from award-winning designers illustrate superb uses of image, type, color, paper sizes, format and printing. You'll also get guidelines for meeting clients needs, creating low-budget designs and using special production techniques.

ISBN 1-58180-152-1, hardcover, 144 pages, #31901-K

➡ This is, quite simply, THE graphic designer's industry bible, containing information you and your clients need to buy and sell work in a totally professional manner. This totally revised 10th edition includes advice on managing your business, negotiating prices and contracts, using new technology, handling licensing and copyright issues and much more.

ISBN 0-932102-11-5, paperback, 465 pages, #31509-K

These books and other fine HOW Design titles are available from your local bookstore, online supplier or by calling 1-800-221-5831.

You know you're a **DESIGNER** *if…*

A	26
B	25
C	24
D	23
E	22
F	21
G	20
H	19
I	18
J	17
K	16
L	15
M	14
N	13
O	12
P	11
Q	10
R	9
S	8
T	7
U	6
V	5
W	4
X	3
Y	2
Z	1